The Modern Magnificat

Women Responding to the Call of God

Jennifer Harris Dault

Editor

Jennifer & Harris Dault

Merry Christmas! 2012

Ps. 101

love, Kathy

Published in the United States by Nurturing Faith Inc., Macon GA,

www.nurturingfaith.net.

Library of Congress Cataloging-in-Publication Data is available.

ISBN 978-1-938514-14-2

For Central Baptist Theological Seminary, my soul mother

Endorsements

"The mark of a disciple of Jesus is a willingness to go wherever you are called. These stories of women answering God's call to ministry powerfully personalize theology debates that detail what women can and cannot do. The one thing a disciple, regardless of gender, dare not do is ignore the call of God."

—Ed Cyzewski, author of Hazardous: Committing to the Cost of Following Jesus and Coffeehouse Theology

"Rev. Jennifer Harris Dault has offered us a gift in sharing the sacred stories of women called to ministry. From dramatic clarion calls to insistent and incessant yearnings of the soul, these poignant stories give witness to the diverse and distinct ways in which God calls and the amazing array of gifts God pours out on women from all walks of life. After reading these stories no argument is needed or defense required for women called to ministry. It is abundantly clear that God calls women to ministry and God gifts women for ministerial leadership."

—Patricia Hernandez, Director of American Baptist Women in Ministry and Transition Ministries for ABCUSA

The Modern Magnificat has accomplished an important task: putting human faces on an important theological issue. I remember when I was first confronted with the question of whether or not women could serve in all facets of leadership within the church. After studying the relevant biblical texts in their historical context and seeking God in prayer, I became completely convinced that women should be liberated for all forms of ministry! As a youth pastor (at the time), I wanted to create an environment where teen girls and boys could discern the Spirit's call into any role within the church. To do the opposite actually works against the potential impact of the Kingdom. So, I implore you; listen to Ali, Jamie, Heather, Katrina, Peggy, and all of the other remarkable stories about a God who declares that both our "sons and daughters shall prophesy!"

—Kurt Willems, Anabaptist writer, speaker, & church planter
[KurtWillems.com]

In the 21st century, when we take for granted the integration of women in all areas of our common life, it is vital to hear the stories of women called into ministry. Harris Dault has given us a window into the particular challenges that Baptist women face. These stories reveal the power of call, the passion to follow Jesus, and the willingness to continually break new ground in often hard and rocky soil. These stories are a must read for women and men who want to transform the church into a more welcoming and affirming place for those called into its service.

—Robin Lunn, ordained American Baptist minister,
Executive Director, The Association of Welcoming and
Affirming Baptists

Jennifer Harris Dault has assembled a collection of eye-opening, life-changing, thought-provoking stories of women called to ministry. These are convincing testimonies that answering God affirmatively, following Jesus faithfully, and yielding to the Spirit completely do not guarantee easy paths. Their journeys include steep hills, deep valleys, sharp curves, and rough terrain, but the collective witness of these pages should persuade readers that ministry is a noble call that is worth the effort. *The Modern Magnificat* is a gift of honest and transparent narratives that stir emotions and invite respect for the wisdom, grace, and grit they portray.

—David Goatley, Executive Secretary-Treasurer, Lott Carey
Baptist Foreign Mission Society

Life is lived and remembered in stories. Stories have formed our personalities, influenced our decisions, and shaped our faith. For ministers, calling cannot be understood apart from the greater story and the individual stories. As a lover of stories, I am grateful to Jennifer Harris Dault for collecting call stories from twenty-three Baptist women ministers, who write beautifully of their formation as Christians, their experience of calling, and their adventures in living out that calling. They are stories of struggle, disbelief, pain, and seemingly insurmountable obstacles, but they are also stories of joy and delight in the hearing and following of God's call. Each story was a reminder for me that God does indeed call, gift, and grace Baptist women for the work of ministry.

—Pam Durso, executive director, Baptist Women in Ministry,
Atlanta, Georgia

Contents

Foreword

For thousands of years, people of faith have offered their stories to each other. *"It rained for forty days and nights." "I used a sling and a smooth stone." "We wrapped him in swaddling clothes and laid him in a manger." "The tomb was . . . empty."*

To hear a person's story is to be given a sacred gift and trust as one human being says to another: *"Here is my path." "Here is what happened to me." "This is what is possible!"* And perhaps the deepest of all . . . *"You are not alone."*

Our stories are some of the best things we can offer each other, so that we can touch, taste, smell, see, and hear experiences within ourselves and beyond ourselves, and so that we can be stretched, comforted, challenged, provoked, and inspired. Of course, it's easy to miss the significance of any gift, especially when we sometimes get off track and start telling other people what their stories should be. But when we listen to what is in a person's life, we discover beauty and riches . . . if we will lean in and pay close attention with hearts willing to be filled.

These pages that follow hold stories about being faithful people of God instead of being successful by the world's standards, following unknown paths by going one step at a time, learning the wisdom of wandering, embracing the surprising, nerve-tingling movement of the Spirit, and dancing with a God who captures us with visions.

There is a word offered here for every believer as we all journey with a God who holds us and calls us into this wonderful mystery called Life. In the

writing and reading, in the sharing and listening, may these be sacred gifts... given and received.

Rev. Joy Yee currently serves as pastor of Nineteenth Avenue Baptist Church in San Francisco, California, where she lives with her husband, two sons, and a cat named Misty.

Introduction

What does it mean to be called by God? How do you know when you've heard God's voice? How do you discern where God is leading? Whom does God call? Might God be calling me?

Calling is surrounded by questions. Am I hearing this right? Am I crazy? God wants me to do what? When Moses was called, his first response was, "Who am I?" Isaiah quickly replied, "Here am I; send me!" But when God shared with Isaiah what that call meant, he questioned, "How long, O Lord?" Sarah laughed. Mary asked, "How can this be?"

Calling is confusing and curious. It often takes us by surprise, inviting us to join God's work in a way we had never considered or dreamed.

For many women, the call to ministry is particularly challenging. Those of us raised in the Baptist tradition were often taught that God simply doesn't call women—but only men—to the ministry. And yet, the Spirit continues blowing where she will, dancing around both women and men, inviting all to join in service. What is a woman to do when she hears that call? How is she to remain faithful to what she was taught, while remaining faithful to the voice of God?

This book is an attempt to chronicle the journey of calling. In its pages, you will find the stories of twenty-three Baptist women who heard God's call. These women are from a variety of backgrounds, spanning Baptist life. You will find Southern Baptists, Cooperative Baptists, American Baptists, Missionary Baptists, Alliance of Baptists, and others. There are women who are committed to being life-long Baptists. There

are women who find their identity in the Baptist church, but have found places of service among the Disciples of Christ, United Methodists, and Mennonites. There are women who are not sure if they will be able to remain Baptist.

Why Baptist women? Baptists are still at a deciding point concerning women in ministry. Most other denominations have either fully embraced women or have blanket rules prohibiting women from the pastorate. I believe Baptist women are in a unique situation, serving in a denomination that will ordain them, but may or may not hire them.

While this book was being compiled, Baptist Women in Ministry (BWIM) released a news report stating that there are now 150 women pastoring or co-pastoring in Alliance, Baptist General Association of Virginia, Baptist General Convention of Texas, and Cooperative Baptist Fellowship churches—the largest number in the history of these groups. The number of women pastoring or co-pastoring in American Baptist Churches is 485. According to the American Baptist Churches' website, the denomination partners with 5,500 congregations. By these numbers, just over eight percent of American Baptist Churches have women pastors.

While there are women who are still being ordained and called by Southern Baptist Churches, the Southern Baptist Convention officially states that the role of pastor is reserved for men. Because of this, there are no real statistics for women serving in Southern Baptist life.

I am honored to be able to share these stories with you. Among the pages are women who have helped shape me: friends, BWIM colleagues, and my ministry mentor. Others are new friends I met through this project. Joy Yee, who graciously wrote the foreword for this book, is the first woman I heard preach. I was a college student at the time. Many others provided help and encouragement along the way. My dear friend, Rev. Kate Hanch, served as a sounding board for this book. Countless friends and family members helped spread the word in my search for stories.

I hope these stories help offer insight into the experience of calling. The words offered here will not make the experience any less mysterious, nor should they. God speaks to us all in individual and personal ways. But reading and hearing examples of how God speaks and calls is beneficial

to all—men and women, ministers and laity. As ministers, I believe it is important to hear one another's stories. It is a reminder that we are not alone, that there are others who share in the wider story.

For a denomination torn over women in ministry, I believe it is important to hear the voices of those who are seeking a place of service. Hearing call stories offers a face—or at least a name—to what is often labeled an issue. When we do not know particular women who are called to ministry, it is easy to make assumptions about what type of woman wants to be a pastor. When we do not hear the stories of how churches and individuals can hurt women, we are content in telling pastoral candidates that they are the best person for the position, but our churches are just not ready for a female pastor.

I have attempted to present these stories in the words of those who wrote them. Wherever possible, I edited only for grammar and clarity. I know you will be blessed as you read their words. The stories you will find in this book are sometimes painful, but they are also teeming with hope and strength. I pray that as you read, you will not only grieve, but rejoice in the many ways God is still working in and through Baptist women.

Charity Roberson

I was late from the beginning. Born twenty-two days after my due date, I was an infant who looked around, taking in the world around her. At my ordination, my father said that he and my mother gave me my name, Charity, which means love, because I was a symbol of their love. They had been reading 1 Corinthians 13 together in the King James one night, where charity is used for the word love and thought, "That would be a good name." And there you have it. Some have said that with a name like mine, what else could I do but go into ministry. The truth is, though, I've been much too polite and concerned with doing the right thing most of my life to answer a call into ministry. My first words were "muse me." I was trying to get out "excuse me." My mother heard a little voice behind her and felt my hands on the back of her legs as she was walking down the hall. Even as a toddler I was polite.

My sister was born eighteen months later and it was clear she was her own person from the beginning. Like most firstborns, I was very concerned with pleasing my parents and others. While that is not always bad, I had to learn that being my own person was not a sign of disrespect; a lesson I would not learn until much later in life.

My sister and I were raised on the parenting principles of Adrian Rogers, who had been my parents' pastor when they were first married. As kids, we memorized scriptures for the reward of Strawberry Shortcake miniatures. We did not play sports or participate in activities that would keep us from church on Sunday mornings, Sunday nights, or Wednesday

nights. Church was what we did growing up. My parents were leaders in Sunday School, and as a result, we were usually the first ones at church each Sunday morning. Some of my favorite moments early in the church were helping the teachers prepare for the Sunday School lesson. My favorite teacher was Mrs. Morton, my Sunday School teacher in the fourth grade. She treated me like a real person and always had tasks prepared for me to help get our classroom ready. I was important to our Sunday School class.

As a reward for my parents' contributions to their former church, Bellevue Baptist, we were sent sermon series on cassette tapes. Listening to sermon tapes was a typical component of our vacations. The tapes I remember most distinctly were sermons focusing on family, defining the roles of men, women, and children. Dr. Rogers preached about submissive wives and husbands that were spiritual leaders. Wives were supposed to bring their husbands pride. As a colleague has put it, I interpreted that to mean that my role in life was to make other people look good. It came through the words of the sermons on the car stereo, Bible studies, the Southern Baptist churches we were members of in Jacksonville, North Carolina, and by the mentors in my life. At the same time God was calling me and developing me into a minister, I was listening to Adrian Rogers, a man who played a key part in making changes in the Southern Baptist Convention with one of the key issues being the role of women, particularly in ministry.

The first stirrings for ministry came in Girls in Action when I was in the first grade. I still remember sitting around our little table in our little chairs hearing the stories of missionaries and thinking, "I'd like to do that one day." At the time, my calling was more wrapped in my attempts to please God and believing God would love me more if I was a missionary. Church was my identity. I did not play sports well. I was smart, but never thought too highly of my own academics. I excelled, though, in being a leader at church, even at an early age. I felt most myself, most comfortable, and most gifted at church. Looking back, God began calling me into ministry long before I had any idea that could be possible.

In my teenage years, I experienced a stirring to something more. It was a call to ministry, but I just assumed it was a call to be a good pastor's wife, or to be a youth minister until I had children. While struggling with my own call, I continued to assume that God did not call women to leadership in ministry. I once led a Bible study for my Acteen group on why the Bible says women should not be ordained and were not called into leadership in ministry. My pastor's wife, who was an ordained chaplain even though we were a Southern Baptist church, sat in on the Bible study, but just slipped out sadly near the end of my talk. She never brought up the topic with me after that.

The summer after my junior year in high school, I served as a summer missionary. I continued to serve every summer after that until I graduated from college. Each summer, I would start planning where and how I would serve the next summer. I was actively involved in my Baptist Campus Ministry in college and with a friend started a church outreach team. Rev. Geneva Metzger was my campus minister. I knew that Geneva loved us dearly, but in my mind, she confirmed all of my earlier beliefs about why women were not called into ministry. In my mind, I was involved in this campus ministry despite the fact that Geneva was the campus minister. While I have grown to appreciate her leadership and involvement in my life in more recent years, we never had the discussion about women in ministry. My perception was that she was very angry about the topic and judgmental of my beloved Adrian Rogers. Though I later learned that she was right to be angry and the truth about Dr. Rogers, I felt I had nothing to learn from her on this matter. However, she and other women I encountered in college began cracking open my heart to see that God might have created me for something more than to play a role in a family.

After graduation I taught eighth grade science. Even though I was a full-time teacher, I started the Fellowship of Christian Athletes on our campus, started a singles ministry, and helped to lead the youth ministry at my church. Still, I was not sure God had called me into ministry. I'm not sure what kind of sign I was waiting for in order for that to be settled. More and more, I felt God calling me to seminary, though. I was not sure

what would happen after that because I did not have a vision for how God could use me, but through a series of events and some very divine moments, I knew that God was leading me to Campbell Divinity School.

In seminary I felt honored but not pushed. I learned a different way to interpret Scriptures and had a safe place to ask questions. I was not ready to ask too many of them just then, but I learned what to do when the questions would come later. I was valued for where I was theologically but was lovingly taught, as one professor once said to me, "That is one way to look at it, but maybe there is another way to understand the Scriptures."

A journey of heart and calling started in divinity school and continued as I accepted the position as Raleigh Area Baptist Campus Minister at North Carolina State upon graduation. There was still a part of me that believed God had created me only to play the role of wife and mother and that full-time ministry was something I was just doing for a season. However, the longer I served, the more I knew that God was calling me as a minister, not for a season, but for life. I began to intrinsically understand that God had created me as a minister. I was a child of God that might be a mother and a wife one day, but I was also a minister. The most lovely and valued piece of me was not tied to any role I played or did not play, but to the fact that I simply existed. I was a beloved child of God, plain and simple.

When I was ordained in June of 2007, I did so as a sign of complete surrender to the call to ministry. While my family was supportive, not everyone I worked for and with was supportive of my decision. To add to their concerns, I had my own. If God had not created me to only be a wife and mother, what had God created me for? If my value was not to be the best godly wife and mother, did I have any value? I was having an identity crisis, and I began meeting with a coach on a regular basis and began to birth a new identity for myself. I grieved the person I was never going to be, the version of myself I'd always valued. It was the version of myself I thought God valued. In the process, I learned who I was beyond the roles, beyond the job, and beyond the outside voices.

In the spring of 2009, I began to see a pattern at work in my life. By this time, I had entered into coach's training myself and was taking on clients, all of whom were women. My office was becoming a revolving door for young women seeking advice. My staff was female and required a lot of my leadership. I took students to our annual spring conference, but at the end of the weekend, I realized I had not attended any of the sessions, any of the worship, or any of the social times. I had spent every available moment of the weekend counseling women of all ages. From college students to adult campus ministers, it seemed women were being drawn to me. God was at work and it became obvious God was drawing women to me for ministry, and I was feeling my heart burdened for women. Having done my own hard work to find my identity, I wanted that for other women.

However, if this was a new key piece of my calling, I had nothing to offer these women. I was still struggling to see how God could love me. How could I find myself in the very male God of my childhood? I reached out to a former seminary professor and asked for suggestions for feminist theology readings. I needed a different view of God for myself and to have something to pass along to these women. I dove into a summer of reading these feminist teachings, working to find myself and a new vision of God in their pages. I knew what the very male version of God was like; I needed to see different ideas of God in order to find a new way of reading Scripture and understanding God. In addition, I read biographies of amazing women and saw biographical movies about amazing women, because I literally wanted my life to be filled with great women.

The fall brought our campus ministry fall convention and one of the worst speakers I have ever heard. This man took on every male and female stereotype possible and stamped God's name all over it. He began every sermon by introducing himself, followed with the phrase, "And my wife is a stone cold fox." Then he would spend five minutes listing all of the physical attributes of his wife, along with a few positive character traits that proved how she was a good wife. I saw what it did to my female students, and I vowed to be part of something different. I remembered

what years of hearing speakers just like this had done to me. I was going to create a different reality. It was my calling within my call.

The more women I talk with, the more I realize that women in ministry face different challenges. Women, even in the most balanced of relationships, take more responsibility for their home life. A female who co-pastored with her husband told me that when she was away, the church would bring her husband and children meals and offer to help with additional tasks in the church. When he was gone, no one brought her meals, and she was still expected to carry the weight of both of their roles. A pastor told me that he realized there were different expectations placed on his associate pastor, who was a female. He said that he and the other male staff members were able to just show up at a potluck, but she was expected to bring dishes to share. These are minor examples of a more complex problem.

Even in most moderate circles, it is often enough to have one woman sitting around the table making decisions. Even then, there is an attitude that says, "Woman, you are welcome to sit at the table, but you have to play like the boys play." The good old system is so entrenched in our churches, seminaries or divinity schools, and denominational polity that we do not even recognize it. A female pastor told me that while being part of a group for young ministers, she felt she was constantly clarifying her concerns with, "I realize this is a 'woman' problem, but . . ." She longed for a group where that was just understood. Since there are usually a limited number of females around the table, we are often expected to speak for all women, but keep our comments brief for fear that we will become "that woman who is always pushing the women issue." In class, when sharing about how difficult it is for women who are objectified in the pulpit, a male pastor said, "I understand completely what you mean. That's not just a female problem. I was totally objectified at a bar last night by this woman I met." He did not see the difference in being objectified at a bar and being objectified behind the pulpit.

Rather than attempting to fly under the radar as women, it is time to have serious discussions about gender differences, blended with discussions about personality differences and leadership differences. Women

need to connect with other women and talk about their needs where those needs are the norm, not just a "woman problem." Women need to be encouraged to have a voice around the table, to understand the different perspective they bring. They need to be reminded of the role women have played throughout Jewish and Christian history. Women who are often alone in their ministry roles need to have support from other women serving in ministry.

That same magical spring of 2009 when God was speaking in other ways, my pastor preached a sermon asking what it would look like for us to live as if we'd met the resurrected Christ. What did it mean to be a resurrected person? The word that immediately popped into my head was "fabulousness." Well, I thought, that is not godly. I need something more like Mother Teresa would say. What would men say if I told them that was my calling. In the coming weeks though, I could not get past the quiet voice that kept insisting that my calling was to "own my own fabulousness and to help others to embrace their own fabulousness." I've been living into that calling ever since. I refuse to hide the fact that I am a woman. I refuse to live my life as an apology anymore. I refuse to act like I must overcompensate to prove that I can do the job God has called me to do. And I will do it all, being my own fabulous self.

Charity Roberson is the pastor of Sharon Baptist Church in Smithfield, North Carolina. She is also a coach and is working on her doctorate of ministry in the area of women in ministry leadership.

Heather Entrekin

It happened at LaSalle Street Church in Chicago when I was almost thirty years old. Up until then, I had never seen a woman preach and never considered the possibility of ministry, despite growing up in the church, having a father and great grandfather who were Baptist ministers, and finding myself drawn to church and church-related work even when I meant to push it away.

But that summer Sunday, with our pastor on vacation, a young woman with red hair and freckles strode down the center aisle during the prelude and took a seat on the chancel. I assumed that she would make an announcement or sing a solo. But when it was time for the sermon, she stood and preached. I paid attention. In fact, I was mesmerized at the sight of someone so young, authoritative, and female behind the pulpit. Her name was Cheryl Wade and she was the associate pastor at nearby North Shore Baptist Church.

Her sermon was about the parable of the pearl of great price. It was excellent I am sure, but I do not remember the words she spoke. What touched me that morning more deeply than words was the message conveyed by the presence in the pulpit of someone who looked and sounded like me. At least two things happened. I experienced a sense of deep belonging, a kind of Celtic thin place where, in poet Sharlande Sledge's words, "the door between this world and the next is cracked open for a moment and the light is not all on the other side." Until that moment I had not realized that this was missing from my experience.

Looking back, I can see that I had been responding to a yearning for this holy belonging, a "God-shaped space," in many ways—babysitting for the chaplain's kids in college, joining churches wherever employment took me, even working for a Christian para-church organization—but in this moment, it was extraordinarily vibrant and near. I understood that I was fully and irrevocably one of God's beloved ones, no matter how much religious tradition and practice might say otherwise. Later, I would come to describe this moment as no less than a taste of the abundant life that Jesus declares he has come to give. I wanted more.

The second effect of my epiphany, although it took years to recognize and claim it, was that the journey toward ministry now had direction and intention. I had encountered someone who had walked that path. It must be possible. It occurred to me that just as a woman preacher had brought to me awareness of God's belovedness, perhaps I had gifts to bring this blessing of abundant life to others. The door cracked open.

Of course, someone stood ready to slam it shut, and it didn't take long. I left the service with friends, twenty-somethings like me. Another woman and I were extolling the sermon and preacher when a male friend cut us off. He quoted a few choice texts from Paul to illuminate the error of our ways and declared that he had almost walked out of the church in protest against a woman behind the pulpit.

Since the church of my up-bringing was not the Bible-memorizing kind, I found myself bereft of proof texts with which to defend myself. Nevertheless, tongue-tied and angry, I knew that my experience with God's hospitality was true.

Yearning to validate my epiphany and perhaps pick up a few scripture verses for use in the next assault upon women in ministry, I enrolled in a class at McCormick Theological Seminary. It was a New Testament course taught by a Harvard-educated woman who brought vigorous scholarship and a gentle spirit to the task of opening doors to good exegesis for a student who had never heard the term. It was a strange and intimidating world to me, this class of young men, mostly, who used words like "koinonia" and "kerygma." They brought an earnest confidence to biblical study that made me uncomfortably aware of my shortcomings. But

the professor did not disparage my budding effort. She valued it and pushed me to grow, a lesson I have tried to embody in ministry ever since.

The first course led to another and another. This was an academic experience that not only stimulated my mind but stirred my soul. When a full-time public relations position at Central Baptist Theological Seminary in Kansas City offered the opportunity to earn a living and complete the Master of Divinity degree at a reduced tuition, I took it. In addition, this was an ecumenical seminary with American Baptist roots consistent with my heritage.

Throughout my extended, part-time academic pursuit of the divinity degree, however, I did not consciously consider pastoral ministry as a possibility. Apart from my encounter with Cheryl Wade and a female adjunct seminary professor or two, there were not many examples to model or encourage that direction in ministry. A few seminary staff and faculty members advocated for women in ministry, but many persisted in old school prejudices and paternalism. Then there were those who spoke words of affirmation, but whose actions painfully belied their words. I found myself reduced to tears more than once at a professor's insensitivity to gender equality or a choir director's dismissal of my request for inclusive language. Further, as a preacher's kid, I carried the burden of an insider's view of the hardships pastors and their families endure. It did not occur to my father that a daughter might follow him in ministry. And my mother, less than enamored with parsonage living, church pettiness, and meager salary had always advised, "Don't marry a preacher."

And yet, I thrived in seminary. Even without clear vocational focus, theological study was life-giving and drew me in. Again, it was in a New Testament course that I encountered a gifted teacher who blended academic excellence with a compassionate spirit that nurtured his students, especially the ones who did not fit the traditional seminary mold. He himself was exceptional, having come to Christian faith through missionaries in his home country of Burma and having overcome daunting cultural, racial, and geographical barriers on the way to a professorship in a theological seminary in Kansas. He demonstrated that a humble spirit and sharp intellect did not have to be antithetical. His caring spirit sometimes

led him to sing tribal songs of his childhood to keep us alert in late night classes. All of it invited me to find a living word and enduring truth, even in the Pauline texts that had once caused such distress.

Seminary enabled me to imagine that someday I might contribute to a church like LaSalle Street Church where, in addition to welcoming a woman into the pulpit, the lively liturgy had room for both old gospel songs and rock cantatas, homeless people were served breakfast in the church hall on Sunday mornings, and church members marched downtown in peace protests. I loved the church more and more as I grew in understanding of its history, mission, and hope. Enduring friendships took root.

One day, the women's group of First Baptist Church of Paola invited me to preach on Women's Sunday. Now it was my turn to stand behind the pulpit. The women recognized a calling I'd been reluctant to name and affirmed it. Like most beginner sermons, this one was overly ambitious and dense, but sincere. The pastor graciously complimented it, and the women took me to lunch after the service to celebrate my incipient gifts for ministry. Long after I became an ordained minister, one of those women periodically appeared in worship, beaming.

After two years of seminary (and four to go), tiny Centerville Community Church in remote farmland sixty miles southwest of Kansas City invited me to be their bi-vocational pastor. I learned to recognize milo growing in the fields, worry about soybeans shattering in a drought, and share the sorrows and hopes of God's forgotten, beloved ones as I served and was formed by this down-to-earth little congregation in the middle of nowhere. The church moderator, who was also a carpenter, carved my name under the church's name into a thick walnut plank for a sign beside the front door: Heather Entrekin, Pastor. And so, gradually, with patience and grace from the congregation, I lived into the title and began trusting my calling.

Marriage, two years of teaching English in China, and a Ph.D. in communication studies at the University of Kansas satisfied longings for family, adventure, and further education in preparation for a still undefined ministry. But step by step, the journey led to Prairie Baptist Church

in Prairie Village, Kansas, where I was an active volunteer, then held a part-time position working with small groups and later, older adults. The church had moved beyond many conservative Midwestern Baptist counterparts by electing women to the diaconate, welcoming women seminary students as interns, and having ordained women in associate ministry positions. But in its almost fifty years of history, all the senior pastors had been men. The current senior pastor, however, was a genuine and persistent advocate for women in ministry who invited women to preach, used inclusive language, and treated female colleagues with respect. Once he asked me, "Wouldn't you like this job?" prompting me to consider the possibility that I would, actually.

In no small part because of his advocacy and example, the search committee asked if I would be a candidate for the position when he announced his retirement. I said yes, grateful for what I presumed was a courtesy candidacy and glad for the opportunity to experience a search process from the inside for use sometime in the future. Since I did not think that I was a "serious" candidate, I enjoyed the interviews for what they taught me about myself, and because they enabled me to share about my experience of the church.

Then, I was surprised to discover that I was one of two final candidates and, at last, that I was the person the committee had chosen to present to the church to become our next senior pastor. Trusting God to speak through the gathered body of Christ, I accepted a call that had been branching for years, even before Cheryl Wade preached that sermon at LaSalle Street Church, watered and warmed by long-suffering Sunday School teachers, Baptist Youth Fellowship leaders and many more. Though my father never suggested ministry in so many words, he had trusted me to tell a children's story or two as a teenager and later, on the occasion of my installation as senior pastor, passed on the yellowed, brittle little *Star Book for Ministers* by Hiscox, that had belonged to his grandfather, the Rev. John G. Entrekin, in 1879.

One never walks this journey alone. There were many who brought encouragement, faithfulness, wisdom, and friendship to the calling forth of my own giftedness, stubbornness, and joy for ministry, some

unintentionally. Mine was not a straight path, nor a smooth one. I started later than many and took a long time finding focus and conviction of call. On good days, I am grateful for all of it and trust that nothing separates us from the love and purposes of God and nothing in life is wasted.

I believe that one's vocational journey is life long and mine moved in a different direction after 11 years as senior pastor at Prairie Baptist Church. Central Baptist Theological Seminary, my alma mater with whom I maintained close ties since graduation, extended a call to come back, this time in a teaching role and as director of a new Doctor of Ministry program. With the Rev. Dr. Molly Marshall at its head, our seminary has an abiding openness and commitment to partnership with God, who calls all creation beloved. My calling to receive and share the gift of abundant life continues. I give thanks for each one whose spirit has joined God's Spirit in opening doors to the work of abundant life, so that I may open doors for others.

Heather Entrekin is Des Peres Associate Professor of Congregational Health and Director of Doctor of Ministry at Central Baptist Theological Seminary in Shawnee, Kansas. Previously, she served as senior pastor of Prairie Baptist Church, an American Baptist Congregation in Prairie Village, Kansas.

Cynthia Saddler

As a young girl of twelve, I managed the household of a family that lived in our neighborhood. The family was on welfare and received food stamps. I was good friends with the oldest daughter in the family. There was also a son around six or seven who was developmentally delayed or "retarded" as he was called back in the day. My friend visited our house daily because her home was filthy and chaotic. Hanging around with my friend, I noticed that after the first week of the month, there was never any food in the house. The week they received their checks and food stamps, the kids had popsicles, cookies, candy, and hot dogs—it was a kid's junk food paradise. The balance of the month, they ate pork and beans and whatever was given to them, or what they could charge at the neighborhood store. They usually ran up a huge bill at the corner store, charging food and other items to last until the end of the month. The mother had some mental health issues, and the father was a much older man unable to hold down a job. This family had a plethora of children; half of them (three or four) were older than me and the other half much younger.

One day I happened to be at their house around the first of the month. I explained to them how my mom shopped and asked if they wanted me to help them to create a budget like my family. They agreed. That month we paid off the credit at the store and then negotiated with the store to set a limit on the amount they could charge. Each month they turned their monthly checks and food stamps over to me. I would go

shopping for the month, pay all the monthly bills, plan monthly menus, and give them a weekly allowance. I also read their mail to them and explained what needed to be done. No one seemed to have a problem with a twelve-year-old child running a household for two fully-grown adults, who were taking directions from that same kid.

The parents in this family did not have their developmentally-delayed son, Richard, enrolled in school because they were told he would never learn to read, write, or function like "normal" people. He was allowed to run wild and was completely unkempt. I would bring him to our house, give him a bath, comb his hair, put clean clothes on him (usually my brothers' clothes), feed him, and read to him. I taught him to read or recognize simple words, write his name, and memorize his address. When school started that fall, I helped the family advocate for Richard to attend school. He was placed in the special education classes. A couple of years later, Richard was placed with a family that helped children with special needs. I shared that story for a reason and will return to it shortly.

Most of my life has been spent trying to understand the existence of God. From as early as I can remember, I have felt this spiritual sensation that until recently I could never really explain. I have always believed that God had His hand on me, but at the same time I doubted if God really cared about me. I have been in situations and circumstances where I should have died, or lost my mind, but for Him keeping me—and still I doubted. When I accepted Jesus as my Lord and Savior, I lived in a constant fear that God would snatch the rug out from under me if I didn't behave or live a certain way. It took many years and exposure to great Christian education to develop a relationship with God that was not based on fear.

When first I began to experience a strong pull that I was to preach the gospel of Jesus Christ, it was a challenge and a surprise—well not really a surprise as much as a shock. I had long talks with God because I did not know if I believed that women were called to preach, and I knew that I absolutely did not want to do it. The church in which I was a member did not allow women preachers. I wrestled with being called to preach, yet couldn't preach at the church where I served because of the belief system.

I thought leaving my home church and attending a church that allowed women was the way to go. That never worked out; there would always be just one thing that didn't feel right. As I continued to struggle, God did a lot of convincing, and I did a lot of bargaining. For example, I thought that the work I carried out with various ministries in the church would fulfill my "obligations." At the time, I worked with the new members, served as hostess, taught Sunday School, helped with the young adult, youth, and culinary ministries, and served anywhere else I thought I was needed. I finally realized that God was not requiring all that "work"—it was me running from having to deal with the call on my life.

I was confused for a long time as a member of a church that did not acknowledge women in the ministry. I even rationalized that I wasn't really called; that maybe I got caught up in some emotionally spiritual moment. God has a way of making things very plain and understandable, even for idiots—sort of like *Called to Preach for Dummies*. After months of insomnia, depression, restlessness, and tears, one night I asked God one more time to make it plain what I was to do. God's answer to me was simply "you know." I said, "Okay, I accept that I am called to preach." So then when I went to the senior pastor of my church, and he gave me the speech on his view of women in the ministry, I had a slight rug-pulled-out-from-under-me moment. But God told me point blank that I would preach at my home church, Metropolitan Missionary Baptist Church, and placed an affirmation in my spirit and on my heart. God simply said "I am faithful." For eight years I held onto the fact that God said I was to preach and that "God is faithful."

Year after agonizing year, I watched men come forth and be embraced as ministers and preachers. There were times I could not leave the worship service before the tears would just pour out of me. The pain was agonizing, and I just could not make sense of why I could not do this thing God said I was to do. I developed bitterness toward male preachers and anger toward God. I felt abused like the women who find themselves in domestic violence situations.

During a Watch Night Service on New Year's Eve, I was finally validated by the church. It was officially announced that I was called to

preach. So many thoughts and emotions churned within me until I felt that I was having an out-of-body experience. Life began to move at an accelerated pace. It was during the preparation of my initial sermon that I was reminded of my childhood.

I had forgotten about the time in my life when I helped the family in my neighborhood. As part of my preparation process, I was to explain the focus of my ministry and prepare myself for that ministry. Prior to this time, I really didn't know that being called "into" the ministry meant anything other than preaching. I knew that you had to study and maybe even attend seminary, which I did for a couple of semesters. It was during this time of preparation that I realized that I had a call on my life to minister to persons who are disadvantaged, misunderstood, and forgotten in our society. This included hurt and abused women, at-risk children, persons suffering with mental illness, and persons who are homeless. It was during this epiphany that I remembered the family from my old neighborhood, and God reminded me that my whole life has been about helping to empower those who needed it the most.

I now understood why all those years ago I changed my degree from business to social psychology, and how I became employed in a job that I did not seek but rather sought me. I excelled at a non-profit organization working with mentally ill adults. I worked as a representative payee managing the Social Security benefits of individuals who were unable to manage for themselves. That job transitioned into becoming a housing specialist within that same agency. I was using skills that had emerged at the age of twelve. God even blessed my work in the church by allowing me to accomplish things I did not have the qualifications or training to achieve.

Once I embraced the call of God on my life, I began to read 2 Kings 4:38–44. The main focus was on verses 38–41, where the servant gathered wild vegetables for a stew for the prophets, and they couldn't eat it because they said there was death in it. Elisha threw flour in the pot, and it became edible. I had no idea what that meant, and I read those words for eight years trying to understand what God wanted me to get out of them. I studied and read, read and studied, and still could not understand

what I was supposed to receive from reading that particular passage. I read the background and historical context, researching all the hidden meanings. I could never get it settled in my spirit. The realization finally hit that I felt ill prepared to speak for God by preaching God's Word. I questioned, "Who am I to minister for the Creator of the universe?" It was only after I had the opportunity to actually preach, that I read the text and immediately understood what I had not for all those years.

I understand now, with certainty, that God had been trying to get me to understand for eight years that I didn't have to worry about making a mistake; God would be the flour. I did not have to concern myself with who accepted me and acknowledged my call to preach. I was simply to preach. I realized that I had been preaching all the time. My pulpit was parking lots, the check-out line at the grocery store, work, restaurants, etc. I used any opportunity to talk about the things of God. I discovered that I have been called to feed God's people from the pulpit, in the streets, or wherever there is a need. In the years it has taken me to be acknowledged in ministry, I have developed a stronger relationship with God. I have learned to trust, to obey, to persevere, to encourage, to be faithful, and to serve. I have learned that my spiritual gifts are discernment, administration, and helps. I have learned how God uses those gifts to minister to the body of Christ. I have learned that God really does love me, in spite of me. I have continued to serve in various ministries—not out of obligation or as payment, but simply out of love.

The freedom to embrace being a woman called to preach has allowed me to experience a newfound freedom. With that freedom I discovered a thirst for knowledge, which in turn has led me to return to seminary. At the writing of this story, I am a senior at Central Baptist Theological Seminary pursuing a Master of Divinity degree. I have accepted another call, which is to pastor a church. I believe all my experiences to this point have happened to make me a strong pastor, who can lead with compassion, patience, integrity, and strength. I will continue on this journey and celebrate the faithfulness of God and be reminded that God will call whom God will call.

Cynthia Saddler is a licensed minister at Metropolitan Missionary Baptist Church. She currently attends Central Baptist Theological Seminary as a Master of Divinity scholar. Cynthia has co-authored one book, Seasons of Wholiness: Inspiration for the Seasons in a Woman's Life. *Cynthia is the mother of two adult children and a doting grandmother to five.*

Jennifer Harris Dault

In my senior year of high school, my English teacher asked the class to write a college entrance essay, inviting us to be creative in our writing process. I chose to write my essay in story form, telling of a girl who had homework to do, but put it off until late in the night because a friend called in crisis. In that essay, I wrote that people were my passion.

As far back as I can remember, I have felt a call to Christian ministry. That call was both confirmed and limited by my home church in Pineville, Louisiana. Like many Baptist churches, our congregation had a strong love of missions and service. As a youth, my summers always included a mission trip. We would travel to other states and work with local congregations or ministries to lead backyard Bible clubs, coordinate sports camps, or do basic construction work. On one of my first mission trips, I was pulling weeds in the host congregation's parking lot. One of the adult chaperones praised me for my work and commented, "You would make a great missionary's wife." I was floored. Pineville's Bible-belt culture had taught me that women were not to be pastors, but surely women could be full-fledged missionaries. After all, what I had observed from the stories of my retired missionary grandparents was that if the man was a missionary, his wife tended to be, too.

Knowing that I could not be a pastor, I thought that I would pursue youth ministry. The churches I knew at the time did not use the term "youth pastor," but instead called the person filling that role the "youth minister." As best I could tell, there was nothing prohibiting a woman

from ministry in general, just the pastorate in particular. But when I approached one of the church leaders with the idea that I might pursue youth ministry, he chuckled and responded that I would likely marry a youth minister. I was crushed. I recognize now that I was likely laughed at because of my quiet nature, not my gender. While I was a leader within my youth group and led my high school's Fellowship of Christian Students (surely the Bible didn't prohibit females from being president of a school club), I was generally seen as quiet, which translated into shyness. Either way, I took his statement to be a sign that I was unqualified, and that I had no place in the leadership of the church.

But while I gave this minister's words a lot of weight, I was—and continue to be—stubborn. I continually sensed that God was calling me to ministry and could not let that go. My mother routinely reminded me of the prophet's words in Jeremiah 29:11, feeling that God placed that verse on her heart to give to me. While I struggled with knowing what my call meant, the words, "For I know the plans I have for you," were always in my head.

So during my last year of high school, I stepped down from my place in the choir loft to tell my pastor that I had been called to "some sort of ministry." I told my congregation that I had no idea what that ministry would look like, but that I knew I was called. I felt deeply affirmed as those who helped raise me stood in line to hug me and speak encouraging words over me. They assured me of their prayers as I continued struggling with my call. While many in the church believed in limited roles for women, they, too, sensed that God was calling me.

Since being a pastor was out of the question, and full-time church work seemed almost as questionable, I began to assume that missions was my only route. I cried as I imagined having to leave the country and those I loved in order to share God's love in a foreign land. While I knew of "home missions," I wasn't quite clear what those missionaries did. My mission education seemed to focus more on those who traveled abroad, so I never considered that I could do missions without learning another language and traveling somewhere very far away. I knew that I felt a connection with many of the young refugees who moved into my

hometown, and I was terrified of being called to a remote village in a land with no roads, no phones, and no internet (which did not matter quite as much as the other two since at that point the internet was only starting to become a known thing and e-mail addresses were not yet common). I would say goodbye to my family and friends and never be heard from again, except through the occasional prayer letter that survived being carried through dangerous forests and over frightful waterways before being placed in a regular mail system. This imagined story was nothing like those of the missionaries that I knew or read about, but it was still what I feared. Nonetheless, I was determined to follow my call wherever it led, so I went off to college with missions in mind.

I went to Southwest Baptist University in Bolivar, Missouri, and declared a major in English (because it would be practical on the mission field) and church music (because I liked both church and music).

My grandfather was one of the early leaders of the Cooperative Baptist Fellowship (CBF), so I'd heard about the mission organization for years, although had only a vague notion of the politics surrounding both it and the Southern Baptist Convention. While I heard words like "moderate" and "fundamentalist" tossed around at family gatherings, I had no sense of what they really meant or to whom they referred. I liked the system of missions I saw in CBF and began looking for opportunities to work with them. The summer after my junior year of college, I traveled with CBF's Student.Go program to Fremont, California, with a team of three others from across the South. I assumed the trip would draw me closer to my ministry goals, perhaps encouraging a desire to pursue life as a missionary. And while that summer transformed me, it did so differently than I expected. The new friends I served with—who were actually members of CBF churches—spoke aloud the things that I had been afraid to dream. They were free to talk of social justice and issues of racism, and they suggested that women were not the only gender that was supposed to be submissive. I returned home knowing missions was not for me and believing that women *could* be pastors. Unfortunately, the idea that *I* could not be a pastor still ran deep. My understanding that I was not qualified to

be a pastor because I was a woman changed only to "I was not qualified to be a pastor."

So I decided that I would minister using my love of English, writing, and people by becoming a journalist. My journalistic love was for feature stories, the sort of writing that allows you to dig down deep in the life of a person. I saw my job as helping others tell their stories. I wanted the stories to reflect the voice of the person I was interviewing. I often had to convince people that they had a story worth telling—a story that others needed to hear. In a strange way, I was trying to build community, by letting people across the county (at the small town paper where I worked for two years) or across the state (at *Word&Way*, the Baptist paper in Missouri) get to know someone they might not have met. I hoped that people would read the stories and begin to see the beauty in the people around them. But while I loved what I was doing, I daydreamed about the church.

When I worked at *Word&Way*, I tried telling myself that my daydreams about working in a church were simply because I routinely talked to pastors, denominational workers, and lay leaders. I was imagining myself in their roles because that is what a good writer does. And yet, I felt what Dr. Molly Marshall has referred to as "the holy discontent." So I enrolled in Central Baptist Theological Seminary's Master of Arts (MA) program. Central was beginning to offer online and weekend classes, allowing me to commute from central Missouri to eastern Kansas once a month to sit in an all-day Friday and Saturday ethics course. In my second ethics course—ministry ethics, which wasn't required for the MA (as it turns out, I was secretly jealous of all of my Master of Divinity friends)—I remember Dr. Terry Rosell talking about ministerial boundaries. In class I kept thinking "there is no way I could do that—I could never be a pastor." When I got home late that evening, I was still thinking about those words when it clicked—I had been practicing those boundaries for years with various acquaintances who would seek me out as a source of spiritual advice. They would pour their hearts out to me, confessing sins they had never shared before. In those relationships I had acted as pastor, accidentally or instinctively imposing ministerial boundaries.

Two years later, Dr. Marshall tapped me on the shoulder and asked me to be a part of a brand new Master of Divinity program called "create." Create is a cohort-based program designed to help prepare students for a rapidly changing world. During our first class—a retreat to a Benedictine abbey—we were invited to practice *lectio divina*, a form of praying and meditating on Scripture. I chose a Psalm and wrote in my journal, "Might God be calling me to be a pastor?" I was so terrified by that thought that I apparently disposed of the journal where I recorded the Psalm and my sense of God's calling.

But the call continued and was confirmed later in the year when Third Baptist Church in St. Louis, invited me to preach my first sermon. It was the season of Lent, and the lectionary Gospel passage was John 12, where Mary anointed Jesus' feet with perfume. I used the passage to talk about the necessity of grief. I knew we had two recent widows in the church, and I wrote my sermon with them in mind. I wondered what on earth I could say to women who had lost a spouse, when I had never been married (at the time I was dating the man who would become my husband). I prayed, and I struggled, and I stood up to preach my first sermon—speaking way too fast, I'm told. But both of the new widows in the church came up to me in tears, thanking me for my words. At that moment, I realized that preaching can be a form of pastoral care, and I've been hooked ever since.

My call to be a pastor is closely tied to my passion for people. The words I wrote my senior year in high school were the words I shared with my create cohort during our orientation—I have a passion for people. I want to join in their journeys, share in their joys and heartaches, and perhaps serve as a reminder of the God who created us, loves us, and holds us still.

While my sense of call has become clear, the journey ahead has not. As I leave seminary, I see few pastoral openings for pastor—particularly here in the Midwest, which has become home for my husband, Allyn, and me. In order to work with a woman pastor for a summer internship, I had to turn to the United Church of Christ. I have spent this year's internship with a wonderful Mennonite congregation because their pastor is

my age and provides another opportunity to see someone like me serving as pastor. I have been told by clergy and laity in both places that there is room for me in their denominations.

I recently began a part-time position as church administrator in a Methodist church. The pastor is a woman who grew up Baptist, but became Methodist when she began sensing her call.

I desperately want to serve in a Baptist church. The Baptists raised me, trained me, and loved me. The Baptist distinctives of local church autonomy, separation of church and state, baptism of the believer, and the priesthood of the believer are things that I hold dear. But I am afraid—deeply afraid—that there is no room for me in Baptist life. I continue to wrestle with this call and listen to the voice of the Spirit, believing that the God who called me will continue to guide me. And I pray that my struggles and the struggles of my female colleagues will help the next generation of Baptist women find a place at the ministry table.

Jennifer Harris Dault graduated from the first create *cohort at Central Baptist Theological Seminary. She and her husband, Allyn, live in downtown St. Louis with their two cats, Sassy and Cleo. She is still looking for a full-time place of service.*

Kathy Pickett

In the spring of 1998, I was working at my desk in the school office when I heard, "Kathy, if I asked you to drop everything and follow me, would you?" I looked around the room, but no one was there. Shrugging my shoulders I returned to my task. A few minutes later, very clearly I heard again, "Kathy, if I asked you to drop everything and follow me, would you?" This time I got out of my chair. I looked in the principal's office; I peaked in the work room—no one! That afternoon the office had been unusually quiet. The other secretary was absent, and the principal was making his rounds. No one had ventured into the office or called needing something in their classroom. The phones had not rung. Thinking I was going crazy, I returned to my work.

About an hour later, the same quiet, clear voice called, "Kathy, if I asked you to drop everything and follow me, would you?" This time I knew and responded, "God, if this is you, I need some time to process what that might mean." Somehow I knew this question required my consideration. Crazy as it seemed, I spent the rest of the afternoon filing, discerning, and finally answering, "Yes, but please don't make me leave my family."

That evening I described my afternoon experience to my husband Allen. We tried to imagine what God was asking. We discussed multiple possibilities of what "dropping everything" might mean. The school secretary had recently quipped, "Kathy, you just need to go work at church, because someone is calling you from there all the time." Allen and I both

were enmeshed in lay ministry there. We participated in almost everything Holmeswood Baptist Church had going on, but working there made no sense. Were we going to be missionaries? A few months passed by and the call event faded from conversation and consciousness.

In May, our youth minister announced his resignation. I gave no thought to how this might connect with my previous office experience. During the interim, I was asked to attend PASSPORT camp as a youth parent counselor for a week themed "Rock the Boat." Throughout the week I had multiple surprising God experiences, all beginning to connect the dots. The night before we left I had a holy experience that made things more clear.

I was standing in the shower praying and processing my camp experience. My eyes were closed and for some reason there was not much light in the room. When I opened my eyes, the lines between the tiles began to take the shape of a cross. I closed my eyes again, thinking I was nuts. When I opened my eyes again, the cross was blazing white. I knew it would burn me if I reached out to touch it. Knowing I had seen the holy, I dashed out of the shower, got dressed, and found the other female counselor. I told her what I had experienced and she replied, "Do you think you are being called to ministry?"

I now knew what "dropping everything" meant. Back home I shared all I had experienced with Allen. His back was to me while he listened and kept working. Unsure of how he would respond, I said, "I think I am being called to ministry. I don't know what that means, but I know I am supposed to quit my job and be open to the possibilities." Immediately he turned around and said, "Go for it!"

For several weeks, I spent every possible evening outside praying and journaling. I created a little altar with candles, my PASSPORT camp notes, and a CD player for music. This became my practice, a ritual of worship and discernment. Then, on Sunday, July 12, 1998, following a music-filled worship experience led by Joseph Martin, I felt God's holy nudge moving me out of the pew. In a holy trance, I moved to the altar and publicly said "yes" to God's vocational call.

Friends and family came forward to hug me. Tears of joy stained my blouse. Tana Clements hugged me, her fragrant perfume anointing and lingering on my skin all day. Before I left, Greg Hunt, our senior pastor, said he wanted to meet and discuss whatever was next. When I got home I called my mom to share my news with her. Looking out a window while we talked I noticed a sparrow perched right in front of me. Throughout our conversation she looked at me while turning and fluffing her wings. She tilted her head back and forth with watchful promise. Each moment, each encounter that day, was vividly alive with holy blessing.

Monday morning I met with Greg. We prayed together and then I shared my story beginning with the school office experience. We discussed the implications for the coming fall and what I might need to do to move forward. I was concerned about all the possible stumbling blocks, thinking that financial and educational restraints would be the greatest. Allen and I had three teenage children at home, how would we continue buying groceries and paying our bills? Then we discussed my gifts, interests, passions, and talents. After a thorough exploration, Greg said, "Kathy, you really have the gifts to be a pastor, or maybe you should consider chaplaincy. Whatever you do, don't get pigeonholed in just one area. If you do, your gifts will seep out all over the place. And, you will need to consider completing undergraduate work and going to seminary."

My euphoria quickly shifted to reality. Was I called to be a pastor? A chaplain? Completing undergrad work, and then seminary, really? How would we afford this? What about our three teenagers? I barely had time to breathe in between their activities. How could I possibly finish two degrees now? After more prayer and much consternation, Allen and I decided the first step was selling our four bedroom, three bathroom, three-story home. I reminded him we had been praying for a way to relieve our debt for over a year anyway. So, we contacted a realtor, and the "For Sale" sign went in the yard.

Fall quickly came and the summer intern returned to college. Greg asked if I would consider serving as an interim youth minister. Of course I said yes! The interim position was a twenty-four hour per week paid position. I oversaw all things youth, attended staff meetings, and participated

in hospital visits. The youth group grew from approximately twenty youth attending to an average of forty. Parents and others encouraged me to apply for the full-time position. I loved what I was doing, so I did. Then I received the academic reminder, "Kathy, you are doing a great job, but you don't have the educational qualifications required."

Reluctantly, I contacted Central Baptist Theological Seminary and began exploring the possibility of enrolling. I knew Central had provisions for students who had not completed undergrad work. I discovered I was a part of a mysterious holy trend. Across the nation the average age of students enrolling in seminary that year was thirty-five to forty-five, many without completed undergrad work. Central provided a way to be theologically equipped and prepared without going back to college first. Students like me could enroll in the certificate program. After completing forty-eight hours of master's level education, while maintaining a 3.5 grade point average, a student could petition to be accepted as a fully accredited Master of Divinity student. Still unsure of how I could possibly do this with three teenage children, what seemed like impossible financial concerns, and honestly, no faith in my academic self, I did not enroll.

The mysterious work of the Spirit continued to move, even when I did not. Putting our house on the market provided the way for the next round of crazy to happen. Within three weeks, we had a cash buyer. Not only did our house meet the buyer's needs, he also said, "I knew this was the one when I saw, 'For me and my house, we will serve the Lord,' on the front door." The proceeds from the sale provided for a down payment on a smaller home, and the exact amount we needed to pay off all our other debt.

We quickly began looking for a new home in our lowered income bracket. We knew a very small house was inevitable. We also wanted to stay in the district where our girls attended school. Our son graduated that summer and quickly left home to join the Navy, helping with the bedroom requirements. During an afternoon drive we found ourselves on Rainbow Lane. At the end of the block we discovered a small three bedroom, one full bathroom, newly refurbished home. It met our financial and school district criteria. Everything was new inside, which made

downsizing feel a little better. We made an offer on the small (did I say it was a cracker box yet?) house and then waited.

Nerves, anxiety, and panic set in. One morning after dropping the girls off at school, I drove down Rainbow Lane to look at the house again. Sitting in my car, looking at the house, I wondered how everything would work. Even though we were scaling way back, I doubted we could afford seminary. Even though a music ministry position had been created to keep me on staff at Holmeswood after the interim, I was not being paid yet. How would two teenage girls respond to bedrooms that looked like walk-in closets, and one bathroom? I wondered if I had made a horrible mistake. Was I crazy? Some folks thought so. Tears began to flow and I headed to work.

I went straight to my office and closed the door. Trying to get a grip, I blew my nose and turned to the desk calendar page. A sweet picture of Noah calling "All aboard" and a plump Mrs. Noah holding a pig greeted me. The knowing artist included the rainbow of God's promise and new beginnings safely above their heads. Considering the scene, I thought, if Noah and crew survived their storms of change with no bathrooms, locked in a boat with all those animals, we could survive the little house on Rainbow Lane.

I was still looking at the promise-filled picture when the phone rang. Dr. Bob Johnson, Central's acting dean was following up on my enrollment progress. He always seemed to call at just the right time. I told him about my morning, so he asked me about my story. I started from the beginning, which now seemed totally crazy. I told him about my week at "Rock the Boat" camp and resigning from my job. I described all the beauty and blessings received when I publically committed to my call in worship. Then I shared about our decision to sell our home. I expressed my doubts about the little house on Rainbow Lane. Before I finished, I told him about identifying with Noah and Mrs. Noah answering their crazy call to load up their family and animals, with no bathroom at all. Dr. Johnson replied, "Kathy, I would like you to share your story at an upcoming Central event."

What a wise man. I shared my story with other prospective students. Then I listened closely as others told theirs. For the first time ever, I felt like I belonged in the academic world. I left knowing I was supposed to enroll, but continued believing my doubt. Then I remembered what a wise friend had said along the way, "Kathy, God did not part the Red Sea until Moses stuck his toe in!"

A few weeks later we made the move to our new home on Rainbow Lane. I made sure Central's enrollment papers stayed out where I could find them. The morning I sat down to fill them out was stormy with torrential rain and gusting winds. Once finished, I signed the papers, stuck them in a large envelope, and headed to the post office for stamps. Rain came pouring down so hard I could barely see. Driving to the post office my doubts and fears began to surface. I clung to my friend's encouragement to stick my toe in and kept driving through the storm. I purchased the stamps, stuck them on the envelope, took a deep breath, and put it in the mailbox. I wondered what would happen next.

When I got back home, only ten minutes later, I noticed our mail had arrived. Sorting through it I noticed a greeting card addressed to me. I opened the envelope and pulled out a beautiful card. I could not believe the message on the front, "As you begin your road to ministry . . ." I opened the card. Inside I found a check with a handwritten note saying, "Kathy, I hope this will help a little bit with your seminary expenses." I turned the check over; it was written for one thousand dollars, a gift from Martha Eike.

I couldn't believe it. I didn't even know Martha Eike. I pulled out the Holmeswood directory; there she was. I called my husband and then called my grandma. My grandma said Martha was in her Sunday School class, but she didn't know anything about the check. Then I called Greg Hunt and asked if I should accept such an extravagant gift. I also shared that I had just put my enrollment papers in the mail that morning. After my conversation with him, I called Martha and asked if I could come thank her in person. On went my raincoat as I headed back out to my car. Through tears and downpouring rain, I drove to Martha's home.

Martha shared that she had been watching me for quite some time and wanted to know more of my story. While we were sharing I noticed the sun beginning to peak out through her window. It prompted me to tell her about my call identification with Noah and how crazy the whole thing seemed. When I told her I had just put the enrollment papers in the mail that morning, she was amazed. Martha understood and encouraged me to keep living into the crazy mysterious nature of God. Over and over again I expressed my surprise and thanks for her generous gift. Even more so, I thanked her for paying attention to what God was up to in both our lives. When I left I thanked her once again for sending her gift of blessing and assurance affirming I was moving in the right direction.

As I backed out of her drive, I could see the storm was indeed beginning to clear. The rain had eased to gentle sprinkles splashing here and there. Sunshine burst through the remnants of the partially cloudy sky. Dazzling light streamed through the clinging moisture. Then the dramatic artist put the finishing touches on the display. I witnessed the most complete, brilliant rainbow I had ever seen. Each color was perfectly hued. God's promise arched from one side of the road to the other, remaining in front of me my entire drive home.

God indeed rocked my boat while providing mysterious affirmation and promise all along the way. I received my letter of acceptance from Central Seminary along with a presidential scholarship. The award provided full tuition for all four years of seminary. I graduated with a fully accredited Master of Divinity degree, *cum laude*, and received the Katherine B. Willard Excellence in Ministry award. Through many ups and downs, my position at Holmeswood grew into paid full-time work within a year. My family grew to love and appreciate our little home on Rainbow Lane. The financial changes and challenges matured our faith making us even stronger. I managed to balance being a full-time mom—including making prom dresses, doing homework during band competitions, attending competitions—with making pastoral calls in the middle of the night.

On Sunday, September 2, 2012, fourteen years later, I shared my call story in an adult Sunday School class. I realized I had never been

asked to publicly share it at church before. I started by saying, "I am writing my story for a book and so much of it sounds crazy, but it is true." We discussed how strange it was that I had not connected the dots of call earlier in my life. Looking back, it had been there all along. Had God been waiting for just the right time to ask the question? Did I get derailed along the way? Does it point to me never seeing or hearing a female pastor's voice throughout my church history? The women in the group nodded their heads yes! One said, "I needed to hear this story. I have had experiences like yours, but have been afraid to believe them." Then a male in the group spoke up.

"I have watched Kathy's story unfold, and I think we are living under the rainbow of God's blessings she brings. She has paved a way for us to embrace women in ministry when there was none. I know she will be a senior pastor soon, maybe here at Holmeswood, maybe somewhere else. We will grieve when she is gone, but rejoice in her faithfulness to God's calling."

Crazy, but true, I continue to move forward believing in my story. Dr. Molly Marshall once said, "When you begin to doubt, when you are challenged, always revisit your call." Women and men need to hear and experience our female stories of call. They need to see the mysterious movement of God working in us and through us. I am committed to living out my call courageously, tenaciously, and wisely, knowing I am paving the way for other faithful women and men who may hear, "If I asked you to drop everything and follow me, would you?"

Dr. Kathy Pickett is Pastor of Congregational Life at Holmeswood Baptist Church in Kansas City, Missouri. She is committed to mentoring women and men exploring their vocational call to ministry.

Kristen White

It was a warm summer evening. I was working as a counselor at Camp Little Cross Roads (now called CrossRoads Camp and Conference Center) for the second summer. There were seven older elementary-age girls in my cabin that week and we were standing with the rest of the campers preparing to go into the evening vespers service. The vesper garden was back in the woods, and before entering it, campers and staff gathered in the large grassy field with a view of the mountains and the sound of the nearby Little Piney River. While we stood in the field singing worship songs together, I looked around at the breathtaking scenery and the beautiful children I had as campers that week, and I had an overwhelming sense that this—ministry—was what God wanted for my life.

My co-counselor, Erin, was experiencing something similar, and our campers were as well. One wanted to recommit her life to Christ. One felt that she would be a vocational missionary down the road. The remaining five asked Jesus into their hearts for the first time that night. What a celebration we had in our cabin that evening! At the beginning of the summer, Erin and I committed that we would pray continually for our campers and believe that God could change their lives. Reflecting on how much our own lives were changed makes me smile. You see, ministry was not my Plan A. Since my preschool days, I wanted to be a mommy. For awhile, I wanted to be a teacher, but I *always* wanted to be a wife and a mom. That was my plan for life.

I had grown up with parents who encouraged me to love God and to be whomever He wanted me to be. They placed no limitations or boundaries on that support. I also grew up in a church that valued missions and sharing the love of Christ with our neighbors. Then at the age of seventeen, there on the mountain at CrossRoads, I began to sense that God was stirring something new in my heart.

Even though it was something I had never considered for my own life, I began nurturing this call to ministry. I talked with people I trusted and admired. I explored various forms of ministry. I began to take my relationship with God much more seriously. Once I entered college, I became active in the Baptist Student Union (BSU). Some friends and I joked that we were majoring in BSU. Having a community of friends to walk alongside me through the college years was so valuable to growing in my faith and continuing to explore my call.

The BSU campus minister during those years was a wonderful woman who lived into her role as a minister with such grace. I learned a tremendous amount from conversations with her and from observing her example. During my BSU days, I served on the leadership team, connecting our students to local mission opportunities, and also on State BSU Council, helping to plan and lead the state BSU retreats. I seized opportunities to go on overseas mission trips to Russia, China, and the Dominican Republic. Being a BSU summer missionary one summer also helped me to further discern my gifts and strengths. BSU was a safe haven, a place where I was encouraged to try new things, to seek God's face more, and to continue adjusting to what life might look like as a minister.

I connected with a local church, where I was greatly blessed and given freedom to serve however I chose. I sang in the choir and on the praise team, worked with the youth group, and played handbells. I also met my husband, Nathan, there, as it was his home church. We were too shy to talk to each other for a long time, but eventually began dating.

A local non-profit that served women in transition and their children allowed me to serve as an intern for much of my time in college. Though it was not a faith-based organization, it gave me more room to grow, to learn, and to explore who I was.

My senior year in college began with a substantial loss. That fall, my dad died of brain cancer. Through the road of grief that followed, I experienced the presence of God in a way I had not known before. I learned a lot about ministry from being *ministered to* in those days. Words were seldom helpful (sometimes they were actually harmful), but great ministry came from those who offered a hug or were simply present with me. I began to think of the role of minister as being the presence of Christ while walking alongside of people on their journey.

After graduating from college, I began work on a Master of Divinity at Baptist Theological Seminary at Richmond. While being empowered and encouraged in my calling, I was also pushed to rethink much of my theology and perspective on God, the church, and humanity.

While in seminary, my husband and I were married, and I continued serving in various ways. My first church staff position—ministering with youth and children—began just a few months later. It taught me about both the power of the pastor in some congregations (for good or for bad) and also dealing with difficult people. In the process, my husband began to sense his own call to ministry.

I was asked be the youth minister at the church where Nathan and I met. It was going great. As I walked across the stage to receive my seminary diploma, I was so confident of my life's path and the church I was serving.

Fast forward five weeks. I was told by the congregation that my services were no longer needed.

The church had just lost a long-tenured pastor who swept any controversial issue under the proverbial rug. The day after he left, all hell broke loose. Members were fighting for power, for control. Without their leader, they were confused about their identity. They forgot that a church's identity is in Christ, not a human. Immediately, the women-in-ministry issue became the topic of heated conversation (yelling). When they realized that they had a woman on their staff, anxiety rose. That issue, coupled with one committee working in a vacuum and with an agenda, resulted in the end of my tenure there.

This congregation where my husband was raised, this place of growth for me as a college student, these walls in which we met, this sanctuary where we committed our lives to each other, this place where we had served . . . the emotional attachment accentuated the break. A job loss is certainly painful enough, but a job loss in a ministry setting seems to be a deeper upset.

The prior confidence I had was completely stripped away. My world was shaken. I questioned everything.

What kind of horrible person / minister must I be to be so dispensable? What could I have done—or not done—to make the outcome different? How is it that this denomination, through which I sensed my call, is now telling me I can't live out that call?

Why did I just spend (waste) three years in seminary and five years before that exploring this calling that has just been thrown back in my face?

Did God even call me to ministry, or did I dream up the whole thing?

While struggling with questions and doubts, a more pressing, practical issue remained. We had to pay bills and the mortgage on the new home we had just purchased to do ministry in this community.

There was no way I was going to look at ministry jobs in my less-than-healthy emotional state. So in the midst of applying to every open non-ministry position that I could find, I went to the mall and applied to a women's clothing store. I think it paid something like $7.50 per hour. While a bit of a blow to someone who had just earned a master's degree, it was $7.50 per hour more than we had.

I wasn't looking for a ministry position at all, but I unknowingly became a minister to my co-workers, most of whom were college students. My husband called me the "New York and Company Chaplain." I also somehow got roped into working with a college ministry and a new church start that met in an art building downtown. There was little-to-no money involved in those, and I know I was anything but a helpful minister in those months, but these gracious fellow ministers (who had also been through junky experiences) gave me a place to have one toe back in

"official" ministry while I began healing. I'm so grateful for grace in my broken moments.

It had been four months since we had set foot in a church. I don't think I was mad at God, but I was not a fan of people. The thought of being in a church building made me sick. But it was Christmas Eve. It felt unchristian to not go to church on Christmas Eve. We found that a church downtown, one we could walk to—more importantly, one that wasn't Baptist—would be having a few services. We chose the 11 p.m. service. It was a beautiful night, so we walked over and entered cautiously. The sanctuary was packed. And we worshipped. We worshipped a God who sacrificially sent his child into a messy world filled with drama and politics and hurt and brokenness. We worshipped the Christ-child, whose birth, life, death, and resurrection brought wholeness and healing to this messy world.

And as we walked back home, listening to the midnight church bells, we slowly began to heal.

One evening, in what was probably the lowest of the low, we sat on the sofa in our living room, and Nathan asked me what my dream job would be. I rambled about how I love missions, students, and getting people outside of the pews and into their communities to serve. My babbling ended with the words, "You know, like WMU or something."

Woman's Missionary Union (WMU) is the mission organization that so powerfully shaped my life. So much of who I was then—and still am—is because of WMU's mission education groups (Mission Friends, Girls in Action, Acteens) and because of that camp, CrossRoads, which is owned by WMU of Virginia.

I thought no more of my dream job description until two days later. Looking through the classifieds of a religious newspaper, I saw a job opening with WMU of Virginia for a Student Missions Coordinator. It was completely consistent with my babblings to my husband in our living room.

I applied, interviewed, and was offered the job. Working with churches, but not in a church, was exactly what I needed at the time. This ministry job helped me to rebuild some of that confidence that I

lost. Through it, I once again feel sure that God has called me to be a vocational minister.

My lifelong dream of being a mother came true with the birth of Anderson in January of 2009, and Callum in June of 2011. I strongly believe that God has called me to ministry and to my family. I continue to sense his provision and presence as I strive to fulfill both callings faithfully.

A new chapter is beginning soon, as I step back onto a church staff as associate pastor. It is terrifying on one hand to willingly go back. Yet I feel strongly that God is leading my family and me to this place. To that end, it is terribly exciting.

Not only do I believe that God called me, but I believe he continues to call me. How that is lived out may change, but the essence of the calling remains. Ministry is not always easy. Sometimes I feel very alone in juggling family and ministry and life. Sometimes I'm too insecure and wrapped up in what other people think of me. Sometimes I wish that Nathan and I had "normal" jobs rather than ministry jobs. Sometimes I still question. All of those things remind me of who the calling came from and who I must rely on for the strength to carry it out.

The words of an old hymn sum up my prayer as I consider my calling(s), my journey, my future—"His faithful follower I would be, for by his hand he leadeth me."

Rev. Kristen White lives in Gretna, Virginia, with her husband and best friend, Nathan, and their two wonderful sons, Anderson and Callum. She serves as Associate Pastor / Minister of Children, Youth, and Young Adults at The First Baptist Church of Gretna.

Peggy Haymes

As I sang the last hymn (which may very well have been "Just As I Am") my heart pounded. My knees felt weak. From my balcony perch in the auditorium at Ridgecrest Baptist Conference Center I could see a steady stream of teenagers coming down the aisle. In Baptist terms, I'd made my "public profession of faith" and been baptized some years earlier. I knew I didn't want to be a missionary, so there was no reason to go down front. Was there?

That night after our youth group devotions I caught our youth minister for a conversation. "Mr. B, do you think," I said shyly, "that God could be calling me to ministry?" "It is certainly possible," Mr. B responded. "What did you think you might do?"

"I don't know, but I like to write," I responded.

"Let's keep talking," he said. And we did. We talked. I snuck out of youth choir to leave the poems I'd written on my pastor's desk, and he and I talked as well. No one ever suggested to me that being a girl had anything to do with anything. A year or two later I stood before that church and declared my conviction that God was calling me to full-time Christian service. Most folks, I think, weren't terribly surprised.

By this time we had a new pastor, and he'd put me to work editing and doing the layout for our church newsletter. I also edited the pastor's sermons after they were transcribed from the audio tape and before they were printed for the congregation.

In those days we had a youth month. For the month of February youth were assigned various positions in the church. The congregation wasn't indulging us by letting us play church, they were serious about mentoring the next generation of church leaders. For three weeks we shadowed our mentors and on the fourth Sunday we took over teaching Sunday School (from keeping the babies to teaching the oldest class), playing the organ, leading the choir . . . and preaching. To no one's surprise, I was asked to be the pastor my senior year. To my surprise, stepping behind that pulpit made me feel completely comfortable and at home.

Shortly before I left for my freshman year at Furman, the Southern Baptist Sunday School Board held a conference on women in ministry. What a great time to be a Baptist woman in ministry, I thought.

So I was a little off on that one.

My years at Furman were a strange mix of contradictory movements. From my professors, chaplains, ministry supervisors, and fellow students I received blessing upon blessing on my calling. By the end of my freshman year, I was taking a lead in planning the Sunday morning campus worship and writing liturgy for much of it. But in the world beyond the Furman fountains, a storm was brewing in the denomination that birthed me, raised me, and educated me. And the powers behind that storm decided that women in ministry would be one of the battlefields.

In seminary it was the same process, only more intense. I received more affirmation, including being asked to preach in seminary chapel. More battles. One summer the Southern Baptist Convention passed a resolution saying women should not be ordained. As we gathered back as a seminary community that fall, my childhood pastor, who was now my seminary president, preached a sermon in which he proclaimed that God's calling was not limited by gender.

I seldom remember sermon titles, not even my own. But I remember the title of this sermon by Randall Lolley: "Last at the Cross. First at the Tomb." Some of us wept with the sheer relief of feeling like we weren't standing out there all alone. Men who mostly didn't have much to gain by it were willing to stand with us.

During my last year it seemed to be the right time to pursue ordination. I was not the first woman my home church of First Baptist, Winston-Salem, ordained to ministry, and not even the second. I had the unusual gift of having the process just be about my calling and my ministry, not a biblical tug-of-war on women in ministry.

The only real snag was that the Sunday night that worked out best for my service was already scheduled for a Lottie Moon Offering special emphasis. The Women's Missionary Union agreed to move Lottie for me. If you were Southern Baptist you understand how huge that is. Lottie Moon is kind of the holy mother for Southern Baptists. Pre-empting Lottie is a pretty big deal.

I met with my committee with much trepidation. The minister put together an impressive collection of folks, but one which I was sure I could not satisfy. On one end was Dr. Charles Allen, retired editorial secretary of the Southern Baptist Sunday School Board, not as conservative an institution as the present day, but even then hardly the bastion of liberalism. On the other end was the Rev. Warren Carr, longtime pastor of Wake Forest Baptist Church and well known as liberal leader and general gadfly. My lord, I thought, there is no doctrinal answer I can give that they will both like.

As a sign of respect, Dr. Allen was invited to ask the first question. He mentioned how many such committees he'd been part of, and how the usual course was to ask lots of doctrinal questions. My palms started to sweat. He continued. He didn't see that there was any need for that. There were certain eternal verities—we all knew what they were; we didn't need to name them. Could I give my assent to them?

Certain unnamed eternal verities? Well, yeah.

Once Dr. Allen gave me his blessing, there was no need for anyone else to debate theology. My council quickly became an opportunity to reflect upon my journey of faith, how I understood ministry and my gifts for ministry, and how God might use those gifts. They asked what sort of ministry I saw myself pursuing. I told them that I didn't know but that I'd experienced a growing love for the rhythms of life in the local congregation. Preaching class and ministry internships showed me how much

I enjoyed preaching and leading worship. My experience in chaplaincy showed me how much I loved journeying with people through the pivotal intersections of life. Where else could I find all of this?

It was a time of thoughtful questions, reflection and, in an old-fashioned way, testimony. I wish that every single minister, male or female, could have such an ordination council. After it was all over Warren shook my hand and said, "Welcome, colleague."

On the evening of the service the church filled with people to bless God's calling in my life. They blessed me with no strings attached. The people who'd given me butter cookies and Kool-Aid in preschool Sunday School classes blessed me. The church librarians who'd helped feed my reading addiction blessed me. People who'd changed my diapers and people who chaperoned my youth trips blessed me. People who'd helped raise me and who'd been family for me blessed me. Who better to bless me? I will always be grateful beyond words for the blessing of that church.

I finished seminary with honors, a new pulpit robe, and a new title of The Rev. Ms.; and no job.

I had one interview shortly after graduation. The interview went well and the committee was ready to recommend me for an associate position. I felt like I was crazy for turning down a job in an actual church with a pastor I already knew and liked. But God's calling wasn't in it for me.

So I said no. No other church called for nearly a year. Instead, I sold clothes in a women's clothing store. I journaled a lot. I prayed the psalms of lament with clenched teeth. How long, O Lord. How long? I'd walk into the store in the morning and think, "Three years of Greek and two years of Hebrew so I can ask if they need a blouse with that skirt."

I preached occasionally, but mostly I waited. How long? How long, O Lord?

I had the opportunity to serve as an interim pastor, and both congregation and interim minister delighted in each other. They were far into the interim process by the time I came, and it was both gratifying and incredibly painful to hear week after week, "You know, if we hadn't already settled on a new pastor by the time you came . . ."

To add insult to injury, I watched as many of my male classmates moved easily into pastorates. I'd been a grader for a couple of seminary professors, one of whom taught classes in pastoral ministry. I'd read these guys' papers and graded their tests. Not to put too fine of a point on it, but I knew I had just as much to offer a church . . . if not more.

But I waited.

Just as I was about to give up and change direction, a pastor called for an interview. College Park Baptist in Greensboro, North Carolina, was looking for an associate. It came down to a male candidate and myself. We were both well qualified and the committee liked both of us. They felt torn about which candidate to present.

Finally one of the women on the committee, Dot Whedbee, spoke up. She reminded the committee that College Park prided itself on supporting women in ministry. Why not put their money where their mouth was? I was called by unanimous vote.

For six wonderful, challenging, bewildering, demanding, joyful years, I had the privilege of ministering among this great congregation. They let me minister without having to make my case for the right to be minister. Those who were not sure at the beginning held their tongue and gave me a chance.

It was hard, but only in the way that any form of ministry is hard. And it was wonderful. I sank my roots so deep into that soil that two years after leaving my staff position, I returned as a member, unable to resist the pull of family.

Two significant events shaped my calling and my life at the end of that six-year period. Out of the blue, I had a call from a college buddy of mine. I knew that he'd helped to start a publishing company, Smyth and Helwys. It seemed that they were starting a daily devotional magazine. Having read the prayers I wrote in college, they wanted me to be the first editor. I had a nearly clean slate—it was my baby. The whole enterprise was so new and so evolving that I always thought we had a Mickey Rooney / Judy Garland "Hey, let's put on a play!" quality to it. Writing has always been my first love and I was grateful when a chance to do just that dropped out of the sky.

The second thing was also out of the blue but nowhere near as joyful. For a month or two I'd been shaken by a tsunami of intense and over-whelming feelings—pain, anger, sadness. I'd been doing some work with a therapist for a while but neither one of us could connect the dots between the feelings that were surfacing and everything we knew of my life.

And then I began remembering. Flashbacks started telling the story that I'd locked away for so long. While there were many amazing adults in my life, I also had the terrible misfortune (and misfortune is much too small of a word) to become connected with an adult who was profoundly abusive.

I'd spent my professional life focusing on other people and their needs, but now it was time for me to focus on myself. It wasn't easy. I'd been very active and very visible, serving as on first board for the Alliance of Baptists and working with the moderate group that was trying (unsuccessfully) to stave off the tide of fundamentalist takeover in North Carolina. I was serving a term on the first Coordinating Council of the Cooperative Baptist Fellowship and was co-chairing the Education Committee. It was important for women clergy to be at the table in these groups, and while I was never under the illusion that I was the only woman who could do such a thing, I'd earned a place. I was known, and I think I was trusted and respected.

And I had to step away.

It wasn't as if I'd been diagnosed with some physical illness that provided an easy explanation as to why I was resigning. Some people were upset with me, and some people questioned me. Looking back now, I cannot remember the answer I gave to them.

I wrote. I edited. I did my own work of healing. I turned down churches who called to ask about staff positions. When the time was right, I did a year's residency in Clinical Pastoral Education and followed that with a Master in Pastoral Counseling degree, mostly because I could. And because, as much as I adored the writing, I missed the face-to-face interactions. I healed some more and in time had the opportunity to staff three-day grief workshops and five-day residential workshops for abuse

survivors. Both the training and the work were like a therapist boot camp, pushing me to work at deep and challenging levels.

It also gave me a chance to model a different kind of minister for people, many of whom had been abused by church and ministers. I had many heart-to-heart, soul-to-soul conversations in those times. For some of them, I was the first minister who was safe. The irony wasn't lost on me—with such a heart for the local church, I was doing some of my most profound ministry with people who'd sworn never to darken the door of a church again. When I made a choice to go into private practice, it was in large measure because it would afford me the freedom both to write as well as to continue staffing workshops.

As I worked to finish my process for licensure as a licensed professional counselor, another opportunity arose. The church where I'd served as interim was looking for an interim again. They invited me up to preach for a couple of Sundays and for us each to consider working together again. There were hints that some wanted me to be considered without the interim title.

This was a dream come true. Fresh out of seminary I would have given my right arm for this chance. Now it was back around again.

Except this time I had to say no. I spent several sleepless nights working it through, praying about it, and struggling with it. This was a good church. I already knew—and loved—many of the people there. Most of all, this would be so good for women in ministry. How could I pass up the chance for a woman to serve another pastorate?

I realized I couldn't carry the load of women in ministry all on my shoulders. Being free to follow God's calling in my life had to mean the freedom to say no to a pastoral position as well as freedom to say yes.

Twenty years earlier I felt called to pastor that church, but that same sense of calling wasn't there now. There were practical considerations, the chief of which being that I felt that it was a time to move closer to my beginning-to-age parents, not farther away. But mostly it was a sense that this time, for whatever reason, it was God who was saying no. Some of them were quite upset with me and some of them understood. But it was clear to me that God was saying no; or at least not now.

And so here I am now. I still have my practice, but I'm doing more and more writing. I preach as often as I'm asked. My own pastor is generous in asking me to fill in and a college friend turned United Church of Christ pastor regularly asks me to fill in for her. Frankly, it's not nearly enough.

As I write this, I have just emerged from a four-year wild ride in which I was hit by a car while biking, moved my folks from my childhood home and cleaned out the house, lost my mom unexpectedly, lost my father by inches, lost two cats, and adopted a second dog. I also wrote a couple of books along the way.

It's a transition time now. With caregiving behind me, where do I go? Where does God lead? Who knows?

When I was a teenager, way back there at Ridgecrest, part of my hesitation (other than the fact that in no way did I want to be a missionary to China) was that I didn't know exactly what God wanted me to do. I'm glad I didn't let that stop me, because I still don't have a clue. Will I return to congregational ministry? Perhaps. Will I stumble upon some entirely new arena? Maybe. Will someone emerge from my past to open a new door for me? Based on my history, I'd be wrong to rule it out. When I thought about writing the story of my call, I knew the only way to write it was as the rambling, wandering, wondering journey it has been.

My calling has been a wandering but not always in a wilderness. That calling has been encouraged and shaped and blessed by people who saw my gifts and made me put them to work, as well as people who stood up for my right to use those gifts. I've also learned that whether my calling means saying yes or saying no, I will not please all people. Being faithful means not needing for everyone to understand or approve. Sometimes I don't even understand, at least not until later.

My calling has unfolded by means of many connections, many of which were invisible to me until after the fact. My call has been a dance of opportunity denied and unforeseen opportunity arising. By now I've learned my role isn't to know exactly where I'm going, but to take the next step as best as I can figure it out.

So the journey goes on and if I have learned any wisdom through these years, it is that I do not know where it will lead. When I get there, it may look nothing like I thought it would. But if I am faithful in following, ministry happens.

And I am fortunate enough to be a part of it.

Peggy Haymes is a counselor, writer, and minister living in Winston-Salem, North Carolina and is the author of Didn't See It Coming: How I faced bouncing off a Buick and other assorted stuff. *You can follow her blog at http://SpiritScraps.com.*

Stacy Sergent

On a recent date, the guy across the table from me asked, "So, why did you decide to go into ministry?"

I felt myself begin to sweat. This is never easy to answer. "Um . . . I don't know that 'decide' is the right word. It was . . . it was a calling."

He laughed in the middle of swallowing his beer, and after a few seconds of coughing, said, "Okay. What's that like? God just shows up one day and says, 'Hey, get up and serve me?'"

"Not exactly." I winced, a little hurt by his sarcasm, and tried to explain the concept of calling in a way that wouldn't sound crazy.

For me, calling has come in stages over a period of about fifteen years. I never heard God's audible voice (which helps with the not sounding crazy part), but I do believe God spoke to me. And what God had to say was—to put it mildly—inconvenient. I did not grow up going to church, except on occasion with my grandparents, and when I started attending weekly services with friends my senior year of high school, I felt strange talking to my family about it. Still, I couldn't escape the feeling that God was pursuing me, and that I wanted to be caught.

A few weeks before graduation, I gave in, walked the aisle of the small Baptist church, and told the pastor I wanted to be a Christian. The congregation welcomed me that day with hugs and tearful benedictions of, "Bless your heart, honey." All that spring and summer, I spent more time at church than anywhere else. In my newborn zeal, I wanted to do everything right. Just as I had always been a straight A student, I did all

I could to be a straight A Christian. I completed the workbook for new believers, prayed and read my Bible every day, never missed church, and volunteered to help out with Vacation Bible School (VBS).

It was in VBS that I was first exposed to stories of missionaries. In the Baptist church, missionaries were spoken of with the kind of reverence usually held for saints. Each night of VBS, we would hear about a different missionary family and their heroic efforts to spread the gospel all over the world. The teachers led the children in prayer for these missionaries, and the children handed over their pocket change to support God's work in foreign countries. On my own, I read about the two women for whom the Southern Baptist mission offerings were named: Annie Armstrong and Lottie Moon. I admired them. Everyone at church did.

When I got the chance to be a missionary myself two years later, through the Baptist Student Union (BSU), I jumped at it. It was only for a summer between my sophomore and junior years of college, and I would get to work at the beach! My small church held a commissioning service, gifting me with money and supplies, and promising to pray for me. The Kentucky BSU held a statewide commissioning for college missionaries, and my pastor and his wife drove hours to be there, joining my parents in support of me. I left for Virginia Beach, and met my team of two other college girls and our supervisor, Carol. Together we led beachfront worship services, gave refreshments and evangelistic tracts to lifeguards, and helped church groups teach Vacation Bible School at local campgrounds. At one campground, many families were French-Canadian, and I was thrilled to use what I had learned in my French classes.

During my "quiet times" that summer, certain Bible verses seemed to leap off the page and work their way into my spirit, refusing to leave me alone. "You are my servant," I read in Isaiah 41:9, "I have chosen you and have not rejected you." In the margin I wrote, *Chosen for what?* I couldn't stop thinking that the words were meant for me, along with others, about belonging to God, following God, leaving my own people to pursue God. The clincher came the day after our 4th of July celebrations, when my Old Testament reading in Isaiah 48 told me, "I am the LORD your God, who teaches you what is best for you, who directs you in the way you

should go." The New Testament reading was John 15, where Jesus said, "You did not choose me, but I chose you and appointed you to go and bear fruit—fruit that will last."

This was not something I wanted to hear. All the chosen-ness and directedness sounded to me like the opposite of freedom. I began to get the sense that my future was not mine to plan, that God had other ideas. It was terrifying. When Carol mentioned during our weekly review how good it was to have a French speaker on the team, she said maybe I could be an interpreter at the United Nations one day. She didn't know that this had been my dream for years, and yet when she said it, it rang hollow. I could no longer imagine pursuing that path. For days I wondered why, then realized it was because something like what I was doing that summer felt more right, more like the best version of myself.

When I shared this with Carol, I asked, half-jokingly, "That's not a call to ministry, is it?"

"Yeah," she laughed. "I'd say that's a call."

The next day I read Isaiah 55:12, "You will go out in joy and be led forth in peace; the mountains and hills will burst into song before you and all the trees of the field will clap their hands." I wrote, *I should not be afraid. Wherever God sends me will be perfect, and He will show me what to do.* Anxiety slowly ceded to joy.

Upon my return home at summer's end, I went to see my pastor, Luke. I shared the story of my sense of calling in detail. "I'm so proud of you, honey," he told me with a hug. Then he sighed. "But you better hang on tight. This could be a rough ride."

Luke explained how things were changing in the Southern Baptist Convention (SBC), how some people wanted to place limits on how women could carry out our callings. "At some of the seminaries, they're even starting to not let women take certain classes," he said. With his usual candor and humor, he continued, "There's a theological word for that. What is it? Oh, yeah. Asinine."

The idea that other people—other *Christians*—would try to stop me from pursuing my calling was a shock. In my quiet times the next few days, I protectively cradled an embryonic sense of myself as minister.

When I came to the end of the apostle Paul's journeys in Acts 28, I read, "Boldly and without hindrance he preached the kingdom of God and taught about the Lord Jesus Christ." With my blue ink pen, I changed the pronoun to feminine, and tearfully scribbled in the space underneath, *If they could write this on my tombstone, I'd be happy. That's all I want.*

When I finished college, I still didn't know exactly what I was called to do, or what kind of ministry to begin. Since I had experience with missions already, and since I had heard Luke talk about wanting to be one when he was my age, I applied to be a Journeyman. The Journeyman program was conceived in the 1960s, a Southern Baptist response to the Peace Corps, and since then, thousands of recent college graduates have signed on for two-year terms as missionaries. In the summer of 2000, I became one of them. After five weeks of training at the Missionary Learning Center in Richmond, Virgina, I was on my way to northeastern France.

Something else happened that summer that impacted my time on the mission field. At their annual meeting, the SBC voted to affirm a new version of their faith statement, The Baptist Faith & Message. The first of two major changes removed wording that gave special weight to the teachings of Christ, so that Jesus was no longer the exegetical standard by which the Bible was to be interpreted. The second change was one sentence: "While both men and women are gifted for service in the church, the office of pastor is limited to men as qualified by Scripture."

As I arrived on the mission field, career missionaries were buzzing about the changes and what they would mean. Some agreed with the new statement; others did not. In theory, that should have been fine, since Baptists by definition are not bound by creeds. "I'm just thankful we have assurances we won't have to sign any kind of statement agreeing with this thing," I heard one missionary say at a conference. "We can carry on our work like always."

But that was not to be. About halfway through my two-year term, all Southern Baptist missionaries, like all seminary professors before them, were ordered to sign their affirmation of the new Baptist Faith & Message. Some who disagreed with the statement signed anyway, counting that

small act of dishonesty a lesser sin than abandoning the ministry they had built over years on the mission field. Others refused and resigned their commissions as a result.

Those two years were confusing and difficult, but I did a lot of growing up. When I returned to the U.S., I was determined to get a seminary degree and begin exploring different avenues of ministry. Visiting Baptist seminaries, I hit another road block. I had forgotten my pastor's warning about the "asinine" changes in women's roles until I was on a campus tour. The tour guide ignored me the whole day, then we passed one of the academic buildings, and he mentioned preaching classes, making sure to tell me, "Of course, you wouldn't need to worry about those." It became clear that the schools I was visiting were not the right environment in which to nurture my calling.

A friend from high school encouraged me to visit him at the School of Divinity at Gardner-Webb University, which was more closely aligned with the Cooperative Baptist Fellowship (CBF). The CBF had formed in 1990 in response to the shift in the Southern Baptist Convention, offering a more theologically moderate option. I visited Gardner-Webb, sat in on classes, met students, and spoke with professors, many of whom had been fired or resigned from Southern Baptist seminaries due to their less conservative views. It seemed like a place where I would be challenged academically and spiritually, taught *how* to think rather than *what* to think. With the blessing of my church back home, I enrolled in Gardner-Webb's divinity school a few months later.

Most of my first classes were requirements for all students, including Introduction to Pastoral Care & Counseling. The professor's assignments required not only academic research, but personal reflection. Our family histories, relationship struggles, and grief experiences became our texts as much as any book. It was the most difficult class I had ever taken, and I wanted more. Pushing myself to confront all the issues I had buried and the theological questions I didn't think I was allowed to ask seemed like important work. When it came time to decide on a focus area for my Master of Divinity degree, I chose pastoral care and counseling.

My only hesitation was that I would be required to do a semester of Clinical Pastoral Education (CPE), a supervised ministry experience in a hospital. I didn't know how to act around sick people, and the sight of blood even on TV made me woozy. I put off CPE as long as I could, until my last year of school. A few days a week, I commuted to Carolinas Medical Center, where I went through the rigorous training to become a chaplain intern. My usual prayer was, "Dear God, just don't let me pass out or throw up." And day by day, I somehow survived visits to the morgue, the oncology ward, the neonatal intensive care unit, and the trauma bay without doing either. I also learned to "claim my pastoral authority" as my professors had taught me, which was very necessary when some patients were downright shocked that their chaplain was (gasp) a *woman*.

About a month into CPE, a surprising thing happened. I started doing more than surviving my encounters with patients. I actually looked forward to them, even the terribly sad or bloody or hopeless ones. All the pain of my past, which I had unearthed during pastoral care classes, became fuel for ministry. Though I had previously felt unfit to be a minister because of my emotional issues and childhood grief, I found that having come through those things made me a good chaplain. God spoke to me through Scripture again, and when I read 2 Corinthians 1:3–4, I felt I'd found my *raison d'être*: "Praise be to the God and Father of our Lord Jesus Christ, the Father of compassion and the God of all comfort, who comforts us in all our troubles, so that we can comfort those in any trouble with the comfort we ourselves have received from God." *That's exactly it*, I thought. *I finally found comfort from all my troubles in God, and now I get to pass on that comfort to other people in their troubles. And I'm good at it!*

Certain that chaplaincy was the path of ministry God had in mind for me, I continued my CPE training after finishing my degree. My year as a chaplain resident was more of a trial by fire than I had expected, but the refining influences of a tough supervisor and a grueling schedule made me a better chaplain. I could not have survived that year without the support of a good church. Much like at Gardner-Webb, I found

myself comfortably in the middle of the theological spectrum at Fernwood Baptist Church, able to disagree with and learn from people more conservative *and* more liberal than I was. It was a wonderful place to be.

One evening at choir practice, I mentioned having attended a friend's recent ordination. The woman behind me, Helen, asked, "Have you been ordained, Stacy?"

"No," I told her.

"Well, is that something you'd want?"

"I . . . I don't know," I stammered, but my face must have given me away. It was something I very much wanted.

"Oh, please, let us do that for you!" Helen clapped her hands in excitement, and before I knew it, she was enlisting others to help get me closer to ordination. To my knowledge, there was no opposition at all within the church. In a few weeks, the deacons had voted to recommend me, and an ordination council—four women, three men—had been chosen. I met with them one evening, terrified that they would grill me on theological issues or ask me to quote specific Bible verses. Instead, they asked about my sense of calling and told me about theirs. We shared our stories, they affirmed the giftedness for ministry that they saw in me, and I felt blessed.

Kelly, the church's former children's minister, told me about her ordination years ago. Her council had indeed grilled her and barely let her pass. The certificate they gave her was the only one they had, engraved with masculine pronouns. Kelly still has it framed, she said, with every "him" crossed out and corrected to "her" in her own handwriting. My ordination certificate had Galatians 3:28 printed at the bottom, leaving no doubt that "there is neither . . . male nor female, for you are all one in Christ Jesus."

On May 31, 2008, Fernwood was filled with my family, friends, colleagues, and professors. It was bittersweet since I would soon be moving to Charleston, where I had been hired as a staff chaplain at Medical University of South Carolina. I didn't know yet that in Charleston I would find another church where my calling would continue to be encouraged and expanded. I only knew that I was leaving. The ordination service I

had planned myself was everything I wanted it to be, incorporating many of the songs, Scriptures, and people who had guided me along the path to becoming a minister. The one thing I didn't plan for was how much I would cry, as loved ones came one at a time to lay their hands on my head and speak blessings over me. Thankfully, someone gave me tissues before I stood up as Reverend Stacy Sergent to give the closing remarks and benediction. It was one of the happiest days of my life.

There was no way I could say all of this to my date who asked what calling was like. I guess it isn't good conversation for a dinner date. He didn't think so anyway, since he never called again. In a way, God did just show up and say, "Hey, get up and serve me." But it took me a long time to hear it, and to figure out what it meant. Today it might mean calming a child while doctors stitch up his forehead, praying with a woman newly diagnosed with cancer, holding the grieving loved ones of a car accident victim, baptizing a dying baby, preaching a sermon for a vacationing pastor, or pronouncing a couple husband and wife. When I first felt the calling years ago, I didn't know I would—or could—do any of that. I look forward to finding out what my calling means years from now. God only knows.

Rev. Stacy N. Sergent is a night-shift chaplain at Medical University of South Carolina hospital, and a very active member of Providence Baptist Church. Originally from Harlan, Kentucky, she sometimes misses the mountains, but loves being four miles from the beach in Mount Pleasant, South Carolina, where she shares a house with her dog, Hurley. She and two friends blog at www.ordinarywonders3.blogspot.com.

Tammy Jackson Gill

I found myself in love with the preacher boy when I was seven years old. He was nine when we attended Vacation Bible School together, and he was so smart and knew so much about the Bible. I realize now that my crush on him was largely for this reason. I was drawn to him more through the years as we grew up in our rural southern Illinois community and he became my first serious boyfriend in high school. He was "called to preach" as a young teenager and was filling pulpits in the Baptist country churches around the age of fifteen. When I started dating him we would attend church together, help with youth camps, Bible schools, and revivals. Friends and family started viewing me as the preacher's wife at this young age. I took it as a compliment even though they would tease me that I did not know how to play the piano and sing.

We were married right after high school, a couple of weeks past my eighteenth birthday. I followed him to Southwest Baptist University in Bolivar, Missouri, without a doubt that I was doing the right thing. I desired to become a Christian psychologist to go along with my role as the pastor's wife and thrived in college as I acquired a double major in psychology and sociology with a minor in counseling.

My dreams as a professional woman in psychology began to clash, however, with my husband's desire for me to be a homemaker and stay-at-home mom to our children. I was not interested in being a housewife and homemaker, and gradually the traditional view for me as the pastor's

wife began to fade as well. In college we began to see "the beginning of the end" for our marriage.

I discovered with the help of some incredible professors in college that I had a real gift for academics and psychology. I was encouraged to continue my education with a master's degree and licensure as a psychologist. I followed their advice and by the age of twenty-seven was a licensed psychologist with a growing private practice.

I continued to view my work as a psychologist as a ministry. Many pastors in the communities where I worked would send me referrals with the understanding that I would work with them in the context of their Christian worldview. With a few years' experience under my belt, I began to reflect on what it was that I was doing. Over and over again the words, "healing grace" would come together. I realized that more often than not the individuals coming to me for help were struggling to accept the love and grace God had given them. This led to the name Healing Grace Counseling Centers for the private practice that grew from the referrals I had through the years.

Healing Grace is where I focused my ministry from 1995 until 2005 when I began to explore attending seminary. Over the course of those ten years, Healing Grace expanded to six locations and employed thirteen counselors for a period of time. With healthcare changes in managed care and challenges related to billing and reimbursement rates, however, we found it much more manageable to remain a smaller practice. It was great fun and quite the learning experience for me through this time.

While my counseling practice was growing, my marriage began to crumble. I think it is fair to say that my husband had trouble supporting my career when his dreams were more along the traditional family lines. We had our first child when I was twenty-nine, and I still had no desire to give up my career to become a full-time, stay-at-home mom. I was able to be very flexible with my counseling schedule to work more when my husband was at home during the evenings and weekends. But it still was not what he desired for his family.

Coupled with this difference in family values was the problem we faced within our church. We were attending a Baptist church together

for several years, but eventually that church began to align more with the Cooperative Baptist Fellowship than the Southern Baptist Convention, and my husband became more discouraged both with the church and our marriage. I became more pleased with this change at church since my own beliefs about women in ministry were already evolving. My husband left this church when it added women to the pastoral leadership team. He took our then two-year-old daughter and began searching for a church more suited to his beliefs. I remained at the church we had been attending.

Somewhere during this time I also received information from Christians for Biblical Equality (CBE) in the mail. I am not sure why I got a postcard from this organization, but it was the beginning of a whole new life for me as a woman who loved God and who desired to use all of herself for God. I began to study more through CBE literature about how God's desire for male and female relationships was one of mutuality, not hierarchy. I learned how many women in the Bible were actually leaders. I learned about the culture of the first century. I learned that women could preach and teach!

One of the books I was drawn to through CBE was titled, *10 Lies the Church Tells Women: How the Bible has been misused to keep women in spiritual bondage* by J. Lee Grady. I asked a group of my friends to study this book with me and in the course of that study one of my friends, Elaine, said, "Tammy needs to meet Molly Marshall." And the vision for what I could do began to come into view. I said, "Who is Molly Marshall?" From there I proceeded to learn about Central Baptist Theological Seminary and the challenges women in Baptist life had already faced and overcome.

My pastor at the time, Chuck Arney, encouraged me in my discernment. He took me to Central Seminary for a luncheon and workshop where I got to meet Molly Marshall. I cautiously began to take steps towards seminary, all the while knowing the risk I was putting on my marriage. My husband was not supportive to say the least. But, at the time I wasn't sure what I was going to do with a seminary degree. I had no desire to leave my counseling practice, I just had this hunger to learn and study more and felt my heart leap with excitement every time I walked onto the campus.

My marriage ended in 2007 officially by the State of Missouri. But by all accounts of what marriage means regarding mutual support and love, it had ended years earlier. I finally said to my husband that I could not stay in the marriage. We had two children at this time and he was going to his church while I went to mine. He also had enrolled and was taking classes through Midwestern Baptist Theological Seminary, a Southern Baptist seminary in Kansas City. I attended Central Baptist Theological Seminary, which is an American Baptist seminary. The two Baptist worlds, which one would think are closely related, are very far apart when it comes to women in church leadership.

I cannot express how hard this decision finally was for me and how little I can put into words for others to begin to understand. My hunch is that more people than not will know what I mean when I say I was "dead" in the marriage and "raised anew" when it was over. As painful as it was to do, it was more painful for us all if I remained.

Holmeswood Baptist Church in Kansas City, Missouri, was a great place for me to gain real experience as a pastor in a church. I was hired part-time as their pastor to children and families while I was still in seminary. Rev. Kathy Pickett had been on staff there as an associate pastor for a number of years, paving the way for women in ministry. Rev. Keith Herron was and still is the senior pastor of this church. Keith and Kathy were both very instrumental in helping me discern my call further, and I cannot say enough good things about how they mentored me during this time. I was at Holmeswood when I went through my divorce and finished seminary. The people of this congregation also are the most loving and supportive to young women entering the pastoral ministry.

My duties at Holmeswood included ministry to children and families as well as occasional preaching opportunities. I facilitated a great team of children's ministry leaders and had the privilege to baptize a number of children. I asked to be ordained while I was serving in this capacity. After meeting with the deacons for discernment, the church ordained me in November of 2008. It was the most glorious day of my life. I was overwhelmed with love and support from family, friends, and seminary faculty. My children were both involved in the service as well. The one

downside to this day was the surprise appearance of my former spouse. He sat through the service taking notes, which I understand he then used to explain to my children how it was wrong for the church to do this. My children will continue to process how their parents differ on this issue for many years to come. I trust God will lead their hearts and minds to greater understanding and peace.

All the while I was at Holmeswood, I maintained my private practice as well and often struggled with how to balance the two ministry worlds. For the most part it worked without incident, but at times I struggled with the guilt on both ends. I often felt like I could be doing more in one place or another. I often would try to decide if I should be focused in one world or the other or try to maintain both the counseling practice and church work.

My time at Holmeswood came to an end after two years. I discerned it was time to put more energy into my private practice again and see what more God might have for me in the future. It was simply time for me to move on, even though I was not sure where I was to go next. I also felt it was time to open up the position at Holmeswood for other women who needed a stepping stone into pastoral ministry. Holmeswood has a unique ability to be a mentoring church with a staff dedicated to training others along the way. It was such an honor to be a part of such a staff.

My counseling practice needed some attention after my work at Holmeswood, to be sure. But it wasn't long after I left the church that I began to miss it. As I continued to explore how I could be involved in church ministry and maintain my practice, I began spreading the word that I was available to supply preach when needed. Because my options among Baptists were very limited, I expanded my availability to preach to the Christian Church (Disciples of Christ) congregations as well. I had several friends from seminary who were a part of this denomination and found them very similar to Baptists and very open to women in ministry.

The Disciples have a structure that requires you to meet with their Ordination and Standing Committee before being placed in any of their churches. I met with this committee for interviews, and upon reviewing my credentials they allowed me to have standing within their

denomination as well. I told this committee that I was not sure I could do much in a church because I needed to maintain my counseling practice but that I would be glad to do pulpit supply in the area churches.

Within twenty-four hours of our meeting, the Disciples Regional Minister contacted me with a need for long-term pulpit supply in a small, rural church in Missouri City. Needless to say, I jumped at the opportunity. I began filling the pulpit at Missouri City in December of 2010. In September of 2011, they called me as their permanent pastor. It is a small congregation that very much reminds me of the little country church I grew up in. I love the rural, hard-working farm folks that make up this community. They have allowed me to use my time so that I can maintain my counseling practice while leading them as a growing body of Christ.

I sometimes wonder if I have betrayed my Baptist roots by pastoring a Disciples church. Baptists helped form my faith from childhood, and Baptists have helped mentor me through my journey so far. One big thing Baptists have taught me on this journey is that God desires I use my gifts. I have a love for God, for studying the Scriptures, and for encouraging people with the wisdom I find there. I have a gift for doing that. And guess what? I am not called to be the preacher's wife . . . I am called to be the preacher!

The reality is that at this time in Kansas City there are very few Baptist churches which allow women to preach on a regular basis. I hope and trust and know that this is changing. But I am confident that God doesn't want me to sit around and wait and wait and wait for Baptists to be "ready" for a woman pastor. God is moving and active and alive. Other denominations have left this "controversy" years ago. The church I now pastor has had women ministers several times during its 150 years of life.

I am so blessed and so relieved to be in a church that does not consider my gender an issue. I am a good leader, caring pastor, and inspiring preacher. Who knows? When my time of service is done at Missouri City, maybe Missouri Baptists will be more receptive to women preachers. I hope to see those doors open for me someday.

As I reflected more on my life through writing this essay and how I responded to my call to pastoral ministry, I have to admit I became more

and more saddened by the loss of my marriage. How disappointing it is that a marriage had to end for me to flourish as a woman and as a pastor. Today I feel no anger or resentment towards my former spouse. I tell my kids that I think of him like a brother that I just cannot live with. He has found joy in a new marriage, and they are expecting a new baby in the months ahead. I am very happy for him and the joy I knew he, too, could find in another relationship.

My children Caroline and Curtis are the most incredible blessings I could ever imagine, and I am so grateful for the marriage we had that allowed them to be born. I would not change a thing in the path I have taken to be where I am today.

God has helped me recover from the struggles of that marriage and the divorce. I have since met a wonderful man who fully supports me in my call to pastoral ministry. Jody Gill lifts me up as he beams with love and joy when I am preaching. He never fails to tell me something he learned from each of my sermons. I met him when I was on staff at Holmeswood. He was attending church with his teenage daughter. He, too, was divorced and wondered if he could ever find love again. He has told me often how much he loved going to church to hear me talk, because the sound of my voice brought him much comfort. My children and Jody have a wonderful, loving relationship. I had no idea that marriage could be this good.

Thanks to the God who called me since the time I was small and to those loving friends and mentors along the way who helped open my ears that I might hear and respond to that call to spread God's good news of love, hope, peace, and healing grace.

Tammy Jackson Gill is a graduate of Central Baptist Theological Seminary and is the pastor of Missouri City Christian Church in Missouri City, Missouri. She lives in Lee's Summit, Missouri, with her husband Jody and two children, Caroline and Curtis. She also continues to maintain a full-time counseling practice at Healing Grace Ministries.

Jamie Washam

I never anticipated a call into the ministry. In retrospect, I feel this is due, in part, to my gender. Few women in the Southern Baptist tradition I grew up in occupy roles of senior staff, so while an abundance of women participate in the church, there are few female pastoral role models. During the final year of my undergraduate studies at the University of Texas at Austin, I began to seek direction, but could not conceive of anything that would sustain my interest for a lifetime. The occupations and subjects before me all seemed to have an eventual bottom. I made my future plans a serious matter of prayer, laid my anxieties and questions upon God and waited.

> *Rejoice in the Lord always; again I will say rejoice.*
> *Let your gentleness be known to everyone. The Lord is near.*
> *Do not worry about anything,*
> *but in everything by prayer and supplication*
> *with thanksgiving*
> *let your requests be made known to God.*
> *And the peace of God,*
> *which surpasses all understanding,*
> *will guard your hearts and your minds in Christ Jesus.*
> *Philippians 4:4-7*

One evening, running late to class, I parked my car by the Presbyterian Church, a block away from campus. I figured they would not tow my car (and they never did, God bless them). Passing by the church courtyard, a rehearsing gospel choir drew me in. I leaned against the wall outside the open door, listening. As I squatted there, a vivid vision immobilized me. I glimpsed myself, decades in the future. My hair was short and graying around the edges. I wore an ankle-skimming black cassock with a long, colorful stole hanging from my neck. I stood in a courtyard filled with mature plants. I knew I stood in a school I'd founded to teach writing, movement, painting, music, sciences, sculpture, theology, math, and drama. Stained glass windows I designed and made hung in the chapel adjacent to the courtyard. The entire vision lasted only seconds, but the clarity of the glimpse of my possible future remains. It clearly included many of my known passions, and a possibility that I'd not before considered: ordination. I stood to go to class, but discovered I could not go far. Tears filled my eyes, making walking impossible. I sat upon the first curb I came to, and a voice I believe to be God's told me, "You will study theology." I responded in the affirmative, and peace and calm flooded through me, the likes of which I had not felt in a long time. I gathered myself, went to class, and soon after, began researching divinity schools. I took a summer and fall semester to save up some money and apply to schools. I began my studies at Harvard Divinity School in January of 1998. The entire process moved within the slipstream current of the Spirit; she closed and opened doors; guiding me past roadblocks and through the proper way. Things came together in a way that was beyond me, confirming my belief that this came from God.

I began my studies, intending to pursue a Master of Theology degree. However, two semesters into my studies, I could no longer ignore the quiet and insistent urging, the water-drip persistence that I become ordained. I prayed for clarification to know this came from God, to understand what this implied. I spoke to numerous individuals about their calls into ministry and ordination, and the ways they integrated it into their lives. I talked to everyone I knew who was ordained, but did some kind of ministry that wasn't in a church. Hedging my bets, yet convinced this

came from God—though still uncertain about what kind of ministry it could entail—I switched my degree to the Master of Divinity program and began moving toward ordination.

I struggled with denominational affiliation. To become ordained as a Southern Baptist woman can entail considerable difficulty. Where other denominations would ordain me without struggle, an enormous expenditure of energy would be required to receive the same opportunity within the Southern Baptist tradition. I called my home pastor, Dr. Larry Ashlock, to seek his counsel on ordination procedure and my calling. His encouragement knew no bounds. He offered to help me become licensed in my home church, and assuaged some anxieties about being a woman seeking ordination. I asked him about church policy on females in ministry. (Only men serve as deacons in the church.) He responded, "You are the first to ask."

He went before the all-male board of deacons and asked if they would be willing to license a woman to preach. The board was divided. One man declared, "Come on, it is nearly the year 2000. We need to get with the program. What are we doing, shutting half of God's people out of these positions?" Another shook his finger in the pastor's face, exclaiming, "Pastor, you were wrong to even ask." Ultimately, in spite of Brother Larry's efforts, my home church was unwilling to license me. I began researching other denominations, and the exploration confirmed my Baptist commitment. Not long before this, I'd started working at Old Cambridge Baptist Church (OCBC), an American Baptist church located near my school, as their Christian education coordinator and children's Sunday School teacher. If you were between birth and fifteen and walked through the door, you were in my class. I switched my membership to that congregation and denomination. OCBC committed to walking with me through the licensing and ordination process. American Baptist Churches USA remains a good fit. I was disappointed that my home church was unwilling to grant me a license (especially since they would readily license teenage boys who felt a call during a summer youth trip, boys who grew into men who are fine firemen and coaches, but not ministers, and I was halfway through my Master of Divinity degree), but my ordination

would happen with or without them. OCBC voted to grant me a license to preach in April of 2000, and ordained me on October 28, 2001.

I had hoped for a formal blessing from the body of believers that helped shape me as a Christian, but perhaps it is for the best. Certain aspects of my theology and practice fall outside of the Southern Baptist mainstream, and it might have made for an uncomfortable fit. Over the years, I've received countless informal affirmations and blessings upon my call and ministry from members, former ministers, and Sunday School teachers from that congregation. I felt that the best way to demonstrate God's hand in my call would be to fully manifest it in my life and practice. The confirmation of my call comes through living into it.

Old Cambridge Baptist cheerfully exploded; then patiently helped me to reconstruct my understanding of what church could be. OCBC is an anomalous community. Where my home church of Crestview Baptist in Midland, Texas, easily has a youth group of eighty-five kids or more, at Old Cambridge I was lucky to get three children on a Sunday morning. The adult Sunday School classes did not conform to my experiences and expectations. Situated in the heart of Harvard Square, the small body of believers can be dwarfed by the imposing building, a gorgeous nineteenth century gothic structure, replete with a two-story high Tiffany stained glass window. During the week, the church buzzes with activity. The basement houses numerous non-profits and social service agencies, ranging from a homeless drop-in center with showers, lockers, and mail services to an Ethiopian women's empowerment agency to a small yoga studio. (The basement was so full, I had to struggle to get a dedicated space for the children's Sunday School class.)

After I'd been there about a year, they entered into a partnership to share space with a local ballet. During the week, dancers stretch and spin in the sanctuary and parish hall. For a long time, I couldn't figure out what made them a church, or what held them together. Over time, they helped me to glimpse the spectrum of what church could be, what was possible, and what was permissible. I adjusted my definitions of "success" from numbers to something subtler, more intimate and intrepid.

In April of 2001, Hyde Park Union Church of Chicago extended a call for me to serve as one of their pastors. I worked as one of their Lilly Pastoral Residents for two years. While there, I began a chaplaincy program at a hospital on the city's south side, shared in worship leadership, and worked with the church youth.

I'd already moved to Chicago, and needed to fly back to Boston for my ordination council and, God willing, service of ordination. The council was scheduled for mid-September. My flight was booked from Chicago to Boston, set to leave September 12, 2001. That flight did not take place. All flights were grounded after the attacks on the World Trade Center, Pennsylvania, and the Pentagon. I rolled the dice (tossed the Urim and Thummim?) and rescheduled the council for the same weekend I'd hoped to hold the ordination ceremony. If they voted not to ordain me, I figured my loved ones and I could just go out to dinner.

The council lasted around three hours. It was tough, but enjoyable in its way. I'd been preparing so long, in so many ways, it felt good to field questions and have the opportunity to say what I believed and why. I chose to not flinch or hold back on where I stood theologically, even if that made the council vulnerable to contention. They needed to ordain me honestly with eyes open, or not at all. After my part of the council ended, I excused myself to wait. It took a little while. Someone came for me. The vote was not unanimous, but it carried. People were gracious afterward, some letting me know how refreshing my candor was; others were more guarded. One woman told me that she had some concerns and would be praying for me. I told her that I coveted and appreciated her prayers and would hold her in mine, as well.

Since 2003, I've served as solo pastor of Underwood Memorial Baptist Church in Wauwatosa, Wisconsin, a community founded in 1843 with a long history of justice and hospitality.

The Reverend Jamie P. Washam pastors Underwood Memorial Baptist Church and lives with her beloved husband and sweet son in Milwaukee, Wisconsin. As an agent of God's love in the universe, she considers it an honor to get paid to do what she would do in her free time, anyway.

Katrina Stipe Brooks

Born into a military family, I always knew my place. I might have been the beloved first born, but my role was to make my father look good. In case I ever forgot, punishment was rendered and boundaries reestablished. Due to the nature of his job, my father had zero tolerance for outside-the-box thinking and free will, which meant I was destined to drive him insane.

My father began to have some hope for me as I entered my teen years and became interested in a military academy appointment. When I cast that dream aside, he cast me aside with the following words, "Don't you know you are not going to do anything special? You are only going to be someone's wife." Like most young women I believed what I thought were my father's words—I was not special and all I was going to be was someone's wife—for a very long time.

Even though it had been a lifelong dream of mine to be a cardiologist, I knew that was one dream I'd never attain. While I was intelligent, I wasn't special, so I set my sights on something I deemed ordinary—nursing. It was close to being a cardiologist, I rationalized, and I could continue something I was getting pretty good at—making others look good. I entered college unsure of who I was, unsure of what I was doing in a Baptist institution, and unsure of why I was in Birmingham, Alabama, when my family was in Okinawa. The combination was volatile as I struggled with the nursing curriculum. The curriculum was not only tough, it punished critical and outside-the-box thinking. I was doomed from the start.

My first clinical was average. So was the grade—a C. The second set of clinicals awarded me probation from the program. I spent the next year resurrecting my grade point average and wondering what to do next. Tony entered my life about that time. He was extraordinary—at least in my mind. His Baptist-ness was confusing to me and his constant use of the word "call" was a mystery. I set my sights on discovering what the word meant. Somewhere along the line I intentionally became Baptist. I liked the possibilities and outside-the-box thinking. Then there was the whole free will and local church autonomy thing. I was hooked.

Much to the dismay of many young women, Tony and I began to date. It was a relationship of opposites. We taught each other things and built a relationship founded on the best of the families who raised us. Becoming Tony's wife was akin to winning the lottery, or so I was told. Everyone seemed to have their own opinion of my worth, but the general consensus was I was nothing special. As long as I made him look good, I had potential. Tony never said those words. He never acted in that drama, but he didn't have to. Others played that role—including my parents.

I began to wrestle with the word "call." In becoming Tony's wife, I thought I'd satisfied my call in choosing to become a minister's spouse. In choosing to make him look good, I avoided responsibility for my own call, my own role in the kingdom. It was a place I lingered for a very long time. Tony entered seminary, our first child was born, Tony's first ministry appointment came, and I settled into life as a minister's spouse and mother, running as far away from my call as possible. I could've won an academy award in the category of most likely to make someone look good. Yet there was a deep brokenness and dissatisfaction brewing within. Nothing I tried, nothing I attempted as a lay person seemed to quench the thirst and satisfy the spiritual dehydration I began to notice in every area of my life.

As Tony considered his first pastorate I felt a holy nudging to go to seminary. Baptist Theological Seminary at Richmond was two and a half hours from the Bethel Community but my draw to the institution was strong. I wasn't sure why, but seminary began calling my name.

Some days I tarried in the possibilities and joy welled up inside of me as I imagined what God might call me to do. Other days I dismissed the call with my father's words, "all you will ever be is someone's wife."

One day I just did it. I mailed in the application, completed the admission packet, and found myself registered for classes. Our church threw an "Off2College Shower" and included me in the group. I received in cash the exact amount of my year's balance. From that moment on, I had to go. Something miraculous was happening, and I knew I had to be a part of it. I began a life of four-thirty-in-the-morning drives to Richmond and living twelve weeks at a time while my family settled into life without mom. Tony became a martyr in the eyes of many as I abandoned my family for something they did not understand. It was then I learned that "this is my pastor's wife" was a cuss word. Nevertheless, I stayed on course. I had to figure out why I was following the call into the unknown—and why the call was so persistent.

I grew to love Old Testament class at Baptist Theological Seminary at Richmond (BTSR). Samuel Ballantine had a gift for unlocking the mysteries and inviting his students into the narrative. Each day was an adventure and I looked forward to class in spite of the C-grade I struggled to maintain. I kept reminding myself that a grade of C meant I was meeting the requirements of the course, but I hated C's. C's meant average, and I was tired of being average. The C kept reminding me: you are nothing special—ordinary. Forget being the mother of two young children, the wife of a pastor, and a commuter student. I was nothing special, and I knew it. I knew it every time someone affirmed my children or complimented my spouse—always suggesting in their comment that I was not worthy . . . nothing special . . . and I believed them as my father's toxic words grew louder.

That day was no different from the ones before. I left the house by four thirty, had a great eight o'clock class, and came into our classroom with a few friends anticipating another great class. Unlike other days there was something extraordinary in the air. Call it what you will, but crossing the classroom threshold was different that morning. The realization alerted me and my anticipation shifted from "what will I learn today?" to

"what will God be doing in this place?" All my senses were on high alert as Dr. Ballantine introduced the day's topic: prophets.

Completely confused, I opened my mind to the material. As Dr. Ballantine unlocked the mysteries of Old Testament prophesy and the role the prophets played, it was as if this lecture was made for me. It even seemed as though Dr. Ballantine was looking straight at me. Midway through the lecture my heart warmed, and I transcended the moment as God spoke to me, "This is what I have for you, Katrina. I want you to be my prophet." My response was immediate. "Do you know who I am married to? Tony is the special one. If I wasn't married or if he wasn't a good pastor, maybe . . . but haven't you heard? I am no one special. I am just someone's wife."

Almost sadly, God responded, "I am not talking about Tony. This is what I have for you." As the voice ended, the classroom returned to normal except for Dr. Ballantine's curious expression. I didn't know how, but somehow it seemed as if he'd been aware of everything. I couldn't move. God had spoken to me; called me and given me a task. The guilt of my response rendered me speechless as the tears flowed. A colleague noticed and invited me to share my experience. After I told my story she asked, "What makes you think this was a call to pastor? What if it was something else?"

It's hard to believe that conversation took place over seventeen years ago. In trying to understand, in trying to run from the implications, still feeling guilty for my response, I continue to wrestle with what happened that day. In flashes of brilliance I have understood and lived out my call, but in way too many other moments I rationalized the event and offered God weak attempts at living out my call. My greatest sin has been thinking I was no one special. After all, I rationalized, prophetic voices are special. They come from confident, beautiful, intelligent, and articulate conduits. Not from people who are only going to be "someone's wife."

Truth is, the call to be a prophetic voice is not a call to pastor. It is a call to be a prophet. One who holds one's self and others accountable to God's statutes, precepts, and laws. As I wrestle with being unable to find full-time employment, not having a home of our own, and what it means

to no longer pastor a community of faith, I find myself understanding more fully the events of that day so long ago.

God's call. God's invitation to be a prophet is not dependent on employment, not dependent on what I call home, not even dependent on me serving as pastor of a community of faith. God's invitation to be a prophet, to use my prophetic voice, to share my prophetic gifts is dependent on my saying yes. It is dependent on me understanding in my core that I am special. Special and called by God to be a prophet in this world. Perhaps ordinary in the eyes of the world, but in God's hand extraordinary as I seek to be a beacon of hope, a conduit of love, and an icon of grace.

What happened that day, in all its mystery and wonder, happened. God called me to join in the adventure of a lifetime. An adventure not always clear and cookie-cutter perfect, but an adventure which involves faith, persistence, and tenacity: the call to be a prophetic voice and follow as the Spirit blows, wherever she blows. My role now is to run into the wonder of it all and savor its deliciousness as healing balm pours over me. The loudest voice in my head, the one that cries "you are no one special," needs to be silenced, even if it is my father's voice.

As parents, we all say things our children hear differently than we intend. I know on many occasions our children heard one thing when I meant something else. I have apologized many times over the years, and I am sure I have many more coming. Just as I don't want to be the toxic voice in their heads, I am sure my father never intended to be the toxic voice in my head, which I allowed to keep me from being the woman I was meant to be.

Or maybe I overanalyzed his comment. Maybe my father only meant to motivate me. It was I who allowed the comment to fester and infect my life. It was I who used those words as a lens for interpreting all other words, experiences, and events. It was I who hurled it at God and willingly took a role subservient to the one God offered me.

All I know is that it ends now. From this day on, I intentionally choose to claim my specialness and fulfill my call. From this moment on, I choose to run into the wonder of it all and as I heal, savor the

deliciousness. I no longer choose less than. I choose to be the prophet God has called me to be.

Oh, may I be found faithful!

Katrina Stipe Brooks is a lay minister at First Baptist Church South Boston, Virginia, where she is having fun challenging small town FBC life and learning to use her prophetic voice as the Spirit blows.

Mindi Welton-Mitchell

I am a fifth generation ordained American Baptist Churches (ABC) minister. My grandfather, his twin brother, and his younger brother were all ordained ABC ministers, as was my great-grandfather and great-great-grandfather on my mother's side. On my father's side, my aunt became an ordained American Baptist minister while I was in college, and in the last few years, my mother received a local ordination from my home church, first as an ordained deacon, then as the local pastor.

I was born in Oregon and raised in Alaska. In my early years, my parents did not go to church, and I remember my mother telling me we did not believe in God. However, by the time I was nine, my mother's own faith journey had led her back to a small start-up American Baptist congregation in the Palmer-Wasilla area of Alaska. I began attending Sunday School along with my brother, where we were two of the three children in the church at the time. My dad rarely attended church, but my mother became a member and later a deacon.

When I was thirteen years old, before I even seriously thought about baptism, I was on vacation with my mother and brother, sitting in my grandfather's church in rural Pennsylvania listening to him preach, and I felt something inside me say, "That will be you someday." Those words hung in the back of my mind for a few months. I don't remember when I told my mother, but it wasn't long after I mentioned to her that I wanted to be a minister that my mother suggested I talk to our pastor about baptism.

Throughout my teen years, I knew I was called to be a minister, but sometimes I hid that call from others, especially my peers. I desperately wanted to fit in, and among my non-Christian friends being a minister was not a cool career dream; among most of my Christian friends, wanting to be a minister as a woman was also not an honored vocation. So sometimes I told people I wanted to be a teacher, trying not to lie, but also not to tell the full truth. However, I do remember telling my guidance counselor my junior year, who suggested perhaps I should be a teacher in a Christian school, as he did not believe that women should be ministers.

My home church was much more supportive. Every summer our church sent us to camp at Camp Woody, off of Kodiak Island in Alaska. My church always paid for every child who wanted to go to camp, so there was no burden on our families. And every summer, the church asked me to share about the week. Over the summers it grew from reporting about the experience to preaching a sermon by the time I was sixteen. I also remember being asked to preach and share my testimony at church camp. By my senior year of high school, my pastor invited me to preach a few times and encouraged me to attend the Pastor's Bible Study on the lectionary during school vacation.

I applied and was accepted to Linfield College, an American Baptist college in Oregon. I became involved with the Student Chaplain ministry by the end of my first year. I participated in many aspects of Christian campus life—from small Bible studies to Campus Crusade for Christ and everything in between, from conservative to liberal in theology. By the end of my sophomore year, I was no longer feeling comfortable in most of the conservative theological groups, because they either told me that women could not or should not become ministers, or the worship services and Bible studies became therapy sessions for those with big guilt trips from past sins. When I began to question traditional biblical interpretations, I was told that to have faith in Christ was to have no questions, for God gave all the answers. This was so far removed from the embracing church life I had experienced, where my questions were encouraged and my personal experiences with God upheld, that I eventually ceased all

activity with campus Christian groups, except for the Student Chaplains, a group where I felt I could genuinely be myself and express my call to ministry. I also attended the local American Baptist church, where I also felt welcomed and nurtured in my call, even though I occasionally slept in on Sunday mornings.

The summer between my sophomore and junior years of college, I went back to Camp Woody as a chaplain. During the weekends between camp weeks, we were invited to worship with one of the supporting churches of the camp and often invited over for Saturday dinner or Sunday lunch at a board member's home. On one of those Sunday lunches, my call to ministry was called into question by a male board member who began to lecture me on what the Bible said about women in ministry. He said that I was condemned to hell for this belief, and that I was corrupting children. He did not allow me to say a single thing, and as I sat there, the tears fell from my eyes. Eventually I got up and left the room as he continued to lecture to everyone else. But as I walked out the door of that house, I remembered the passage where Jesus told the disciples if they were not received, to "shake the dust off their sandals" and walk on. So I did just that. I made sure to stomp my feet on the sidewalk outside of his house.

During my junior year of college two things happened: one, I left the church, and two, I found the church again. In the fall of my junior year I took a course titled "Fundamentals in Sociology," and for the first time began to really peer inside the church as a social construct. I began to peel away the layers of patriarchy and tradition and see that many of my problems with my fellow believers had to do with social constructs, not with Scripture or experience with God. As a result, in the spring, when I studied abroad and lived in Nottingham, England, I decided not to attend church. I went the first Sunday I was in Nottingham with my host family (they were Catholic). After that, I visited a number of church buildings during my time in England and Western Europe, but I made a point of not attending a single church service. However, I did pray. I read the Bible, and I wrote in my journal as a spiritual practice. But I wanted nothing to do with other Christians for a while.

When I returned to my home in Alaska that summer, I went back to church with my mother. I didn't go every Sunday, but by August, I remember that I was glad to be back. That first Sunday we celebrated Communion, and I truly felt like I was welcomed back home, back to the table. I knew God had never left me—and I had never left God—but yet it still felt like coming home.

I applied to three seminaries during my final year at Linfield. I had majored in creative writing, and even though I was slightly tempted my sophomore year to apply for a Master in Fine Arts degree instead, the call was stronger than ever: God had given me a yearning to participate in ministry. Because I had enjoyed the Student Chaplain program so much, I thought I might go into campus ministry. I was thrilled when all three seminaries I applied to accepted me and offered scholarships. I had some difficulty discerning where to go, but I quickly eliminated the seminary I applied to on the West Coast because I wanted a new experience. Living in England made me realize I could live anywhere, and I wanted something new. I was torn between Colgate Rochester / Crozier Divinity School, where my grandfather had attended, and his twin brother's alma mater, Andover Newton Theological School. I visited both campuses; I received similar financial aid packages. I prayed seriously for a couple of weeks, talking with the pastor of the church I was attending in college, who was a graduate of Andover Newton but told me that both were great schools. In conversing with him, I realized for the first time that there was no wrong choice. I prayed some more, and I remember that I woke up one Sunday morning in February and knew I was going to Andover Newton. I told the pastor that day, and he high-fived me, saying, "I knew you'd make the right choice."

Seminary was one of the best experiences of my life. For the first time, I felt I could truly be myself. I didn't feel the need to hide my call to ministry or my more liberal theological beliefs, for all of us were questioning in one way or another. For the first time I was with like-minded peers, and where we disagreed, we had fruitful conversations and learned from each other. I began seminary feeling called to campus ministry, but in my three years there, I remembered that my call, back in my grandfather's

church, was to pastoral ministry. I remembered that voice inside that said, "That will be you someday" as I listened to my grandfather preach. I went ahead and applied for a campus chaplaincy position but when I received my rejection letter, I felt relieved. It wasn't what I was called to do at this time. Instead, the church down the hill from my seminary asked if I was interested in their minister of education position. I applied for it and was called.

Ordination was a longer process. I hadn't known all the steps to ordination when I was in seminary, as my home church was at the time part of Alaska Ministries, where women were not being ordained into ministry. So I needed to switch my membership during seminary to a new church, which ended up being the church I was called to. I learned I had a number of hoops to jump through in the obstacle course that is the ordination process. I call it an obstacle course, though I don't think that all of the steps on the way are intended to be obstacles. I think often our committees on ministry just use outdated models of processes for ordination, models that made sense forty or fifty years ago, but do not make sense in this day and age of student loan debt and poor clergy compensation. I was required to undergo a costly psychological evaluation; have various reports written by various people and committees, which took a lot of time and many follow-up calls; and meet with different committees along the way. As I neared the end of my journey, I was rejected in the process once because my ordination paper was not written in the style suggested by the ordination committee. No one along the journey so far had mentioned anything about my ordination paper, though it was included in all of my paperwork throughout my process. Instead of writing two separate pieces, one about my call to ministry and another about my theology with the various theological topics addressed in separate paragraphs, I had decided to be creative. I thought it would be interesting to those reading to incorporate my call story with my theological essays—to talk about my journey of faith along with my understanding of the Church, God, Jesus, the Trinity, and Eschatology, among other topics. My theology professor, who taught the Baptist Polity class, had thought it was brilliant. A retired minister who mentored seminary students in the

process of ordination also thought I did a good job of thinking outside of the box. However, thinking outside of the box is what stopped me at the last step.

After a few days of simply being angry and frustrated, I gathered my courage and started over. I rewrote my ordination paper to fit the standards exactly as the committee suggested in the guidelines. I gave in-the-box answers. I sent my paper to other professors and ministers to receive feedback. I polished it, sent it to the committee on ministry and was accepted. I was back in the box.

However, by the time of my ordination council, the word had gotten out that not only had I challenged the committee, but some of my supporters had challenged the committee as well. As a result, I had a challenging ordination council. During the week before my council it was on my shoulders to call all of the association churches and try to persuade representatives to attend my council, as there had to be thirty voting members of the association representing two-thirds of the churches in order to hold my council, and no one would do that except me. I also had to print sixty copies of my ordination paper and mail it out. I ended up with thirty-one voting members, just enough to make the quorum.

I was shocked when, during the theological statements portion of my ordination paper, I was questioned about my call to ministry because I was a woman. I had prepared myself for questions on my views on hell and the devil and on eschatology, traditional hang-ups in ordination councils. I was not expecting a direct challenge to my call to ministry. The stress overwhelmed me. I broke down and cried. Previous ordination councils I had attended lasted an hour, maybe an hour and a half at most. Mine lasted two and a half hours.

In the end, besides one abstention, the vote to ordain me was unanimous. American Baptists have been ordaining women for a century; in New England, there are a greater number of women pastors than anywhere else. Our association was known as one of the most liberal associations, so for the challenge to my call to ministry simply to be about me being a young woman (age also played a factor) shocked and saddened me. But I have always known in my heart that I was called to ministry, that God

calls women and men, and that no one can take away my call experience. I know I was called. I know it in my heart.

I served for almost four years as the minister of education (later associate minister for Christian education) in that congregation, and then became the senior minister of a smaller urban congregation. In that second congregation, I truly felt my call unfold. As I put on my robe and stole on Sunday mornings and rehearsed my sermon in my mind, I could not help but recall my grandfather and my family. For over a century, we had led a similar life on Sunday mornings. We got up earlier than usual. We got to church earlier than usual. We spent more time in prayer than usual. We talked to more people than usual. We led worship and preached and often took a nap on Sunday afternoons. As a minister, I felt more connected to my family and to my history on Sunday mornings than at any other time—even family reunions.

Currently I am between congregations. I serve as a hospital chaplain while my husband, a Disciples of Christ minister, is serving in his first pastorate. We moved to an area of the country where there are fewer women ministers, and no American Baptist congregations. However, the call to pastoral ministry remains. I have had the privilege and pleasure of occasionally preaching at other congregations, including my husband's. I have also become a retreat leader, a ministry I was involved in before I ever knew I would be leaving the pastorate. Nonetheless, I know I am called to pastoral ministry. It's in my blood.

The Rev. Mindi Welton-Mitchell is a fifth-generation ordained American Baptist minister currently serving in the Seattle, Washington area. Her husband is the Rev. J.C. Mitchell, who is a Disciples of Christ minister. They have a four-year-old son, AJ, who has autism.

Stephanie Gutierrez Dodrill

My high school sweetheart had just broken up with me. My parents had gotten a divorce the year before. I wanted to get away from heartache, so I chose to go to an all women's college my first year out of high school and give myself time to mend.

It was that year that I really heard God's call to give up all that was dear to me and to follow Him wherever He led. Little did I know what He had in store for me, but once I made the decision to answer that call, I never looked back. And I have not ever been disappointed that I said yes to Him.

I had the great privilege of being raised in a Christian home. My father's parents had immigrated to Kansas in the 1930s from Mexico and my father was the third of fourteen children raised in extreme poverty. He became a Christian in college where he met my mother who had been raised in a Presbyterian home. They were married in 1956, and I was born nine months later in 1957. We always attended church—primarily Southern Baptist churches—my entire life. It was in these churches where I learned to love the Lord, study the Bible, witness to my friends, and give and pray for missionaries around the world. I thank God for this Christian heritage.

At the age of four, I knelt beside my bed with my mother and prayed to receive Christ into my life. I was baptized at nine in a Southern Baptist church in upstate New York. We moved quite often and I had lived in fourteen different houses by the time I was fourteen years of age.

In the summer of 1971 we made our last move as a family to Bolivar, Missouri, where my father taught Spanish at Southwest Baptist College (now University) until he divorced my mother in 1973. Having lived a very protected and sheltered life, I was devastated beyond belief that my Christian parents would ever separate, much less divorce. I was sixteen at the time, and my siblings were fourteen, twelve and nine. My whole world had just fallen apart.

As I mentioned earlier, this tragedy was soon followed by my Christian boyfriend breaking up with me, and so I spent the next year at Cottey College in Nevada, Missouri, trying to reevaluate my faith and begin to deal with the many fears, doubts, and pain those two events had caused me.

I came face-to-face with my own hypocrisy and sin. I had been taught to believe that Christianity was a set of rules and do's and don'ts and that I was basically a good person since I never broke any rules—at least not on purpose! I was focusing on the external values and I was oblivious to the internal ones. I soon saw that I was in need of repentance for my inner thoughts and actions that did not please God. It is so easy to be judgmental and look down on others when you think you are the "holy" one.

God was holding my hand through all this and gave me good solid Christian friends and the opportunity to trust in Him again and give Him my sadness and pain. It was during a Christian conference that year that I felt He was asking me to go into full-time Christian service as a foreign missionary, and I was so awed by His love and power that I knew then I would answer that call and follow Him wherever He led.

The following year I transferred into Wheaton College in Wheaton, Illinois, all set to study hard for four years and then go to the mission field as a single woman; I was burned out on male company—or so I thought! A few months into my sophomore year I met a man who was in my Spanish class, and in spite of my resolve not to "fall in love" again, I did. Mark and I were married in 1977 during my senior year at Wheaton. His first job out of college was teaching high school English and Spanish in a small town of 600 people called Newark, about an hour from Wheaton.

Mark and I both loved working with junior high and senior high kids and those two years in Newark confirmed that God wanted us to be involved in youth ministry on a more permanent basis. We started a small Bible study in our apartment. It grew fast, so we recruited three other couples to work with us who are still great friends to this day.

After two years of teaching, Mark told me one day that he thought he should go on to seminary to complete his studies. I had no idea what a seminary was, but I said "sure."

We packed up and drove out to Pasadena, California, that summer of 1979. Mark's father, who was a staunch missions supporter, encouraged me to take a few classes, too, so I could get further preparation for ministry. I began thinking I would just audit a few courses, but I soon discovered I was passionate about what I was learning and decided to pursue a master's degree. Mark was doing a Master of Divinity, but I did not think I wanted to take Greek and Hebrew. After all, I knew women could not be pastors, so I was content to work on a Master of Arts degree.

My convictions, worldview, and ministry goals were all radically challenged in the course I took from Roberta Hestenes called "Women in Ministry." It was through this class I discovered what a "call from God" was all about, and I began to discover the gifts He had given me for preaching, teaching, evangelism, and discipleship. My conservative background kept raising its head and telling me that women weren't allowed to do the same things as men in ministry, but Roberta's teaching changed my mind once and for all. I began to study in depth the "difficult passages" in the New Testament about women in leadership and to look at how Jesus dealt with the women in his ministry. My whole concept blossomed as I saw the Scriptures as a whole and not just a few verses taken out of context to rubber stamp how things had always been done.

Ironically it was the men in my life who made me see I was gifted and called to ministry. My father-in-law encouraged me to study alongside of Mark and prepare myself in the same way. My pastor, George Van Alstine, who is still the pastor of Altadena Baptist Church in Altadena, California, was the key person who helped me discover the gifts God had given me. He also allowed me to use them in his congregation as Mark

and I led the youth group and preached there. Pastor Van Alstine encouraged me to pursue a Master of Divinity degree and become ordained. He was the pastor who believed in my calling and gave me the wings to fly with it. My maternal grandfather, who I thought would have the most reservations about my seminary training and subsequent ordination, was my biggest proponent and flew out with my grandmother from Ohio to join in the celebration of these events. He had instilled in me a love for foreign missions. When I visited his home each summer as a young child, we would pray for missionaries around the world that he supported and encouraged in their task of taking the Good News to all the world.

Mark and I went through separate ordination councils and were ordained on June 13, 1982, the day after we graduated from Fuller Theological Seminary.

This radical step I took was not looked on favorably by my mother-in-law. She was angry that I would try to rise above my ranking in life as a wife and literally steal away the glory from my husband, her son, who deserved to be ordained. She screamed those words over the phone at me, and I was quite surprised she even came out to the event. However, she hardly spoke to me at all that weekend.

During our three years at Fuller, we had decided to join the Baptist General Conference denomination, and I was the first woman in over thirty years who had been ordained. I thought they might want to write up something about this in their denominational magazine, but I was sorely mistaken. I think they were all just relieved that I was going overseas with Mark and would not be able to rock the boat over here and give other women the radical idea that they could be called to ministry, too.

My journey as a missionary in Youth for Christ for the past thirty years in the country of Spain is way too long to try to describe here, but I want to say I have had all the freedom in the two different local Baptist churches we have attended to preach, teach, and serve without any discrimination or prejudice. I have been a spokeswoman for women in more restricted places of worship. These women are truly gifted and have been hindered in following the call God has placed on their lives due to traditions and misunderstanding of Scripture's teaching on this issue. I

have given talks and conferences on women in ministry in many places in Spain. I count it a privilege to be an ambassador for women who are not taken seriously or encouraged to follow God's call. I highly recommend the group Christians for Biblical Equality in the U.S., which has provided the resources and conferences to make it possible for me to stand up and speak out on this issue. In the majority of Christian bookstores in the States you cannot find any of these books.

Fortunately since Youth for Christ is an interdenominational mission organization, we work with all the local churches in Spain. We have been able to empower many women whose churches stifle their abilities, by allowing them to exercise their gifts for evangelism and speaking ministries in our youth center, camps, and adult training events all over Spain.

I want to thank Jennifer Harris Dault for the opportunity to write about my calling. It was her grandfather, Rev. Harlan Spurgeon, who was my pastor at First Baptist Church in Bolivar, Missouri, in the 70s. God has granted me many opportunities to serve Him and continues to do so as I obey this call and work out my salvation in fear and trembling, knowing that He who has called me is faithful, and He will do it!

Stephanie Gutierrez Dodrill has a Master of Divinity from Fuller Theological Seminary and has been serving as a missionary in Barcelona, Spain, since 1982 with Youth for Christ. She is married to Dr. Mark Dodrill and has 3 adult children and 1 grandchild.

Bonnie Bell

Isaiah's call story rings true for me. When the call came, "Whom shall I send and who will go for us?" Isaiah quickly responded, "Here am I. Send me." I have never been one to look far ahead and measure the consequences; I'm more likely to just jump in. I've been less than practical in following the call sometimes. I cling to a statement shared by a visiting Romanian missionary, "God does not call us to be successful. God calls us to be faithful." I have always tried to be faithful to God's call as I understood it, and that has not made for smooth sailing. Following that call has been the most important element of my life's journey. Describing something so personal is more than a bit daunting.

I am a second career minister, but just barely. Near the end of college, I was a student teacher, then a paraprofessional teacher's aide at the school where I did my practicum. I was very involved in my home church—choir, committees, a Sunday School class for high school and post-high school learners. One of the high school boys wistfully stated that he wanted a youth group like the one his older sister had enjoyed. I heard him and understood his sadness. Shortly after this, our pastor invited anyone who saw a ministry need to talk with him. I believe that God was working through that boy and the pastor to help me perceive my first call to ministry. I believe God was at work in my life in those months of planning and launching the church's youth ministry. I had mentors from within the set of families who comprised the group. Several

were seminary-trained ministers and home missionaries who were active members in our progressive and welcoming congregation.

The youth became a vital part of the church, sitting in the front pews, leading worship, special music, programs of stewardship, workdays—you name it. I spent all my free time and energy on the youth group, which blossomed and offered vitality to the church. I began to feel that this satisfied my deeper passion more than the teaching, which was my occupation at the time.

I tried to articulate this beginning of a call to my parents and my pastor. It was something that my mother seemed to sense, saying, "Maybe this is your calling." I'm pretty sure she didn't fully know what that meant at the time. Still, she knew something was happening, and God and the church had something to do with it. When I met with my parents to tell them what I was experiencing, it was as if they already knew. Dad was more familiar with the church and had a close childhood friend of his enter the ministry. They were both very supportive of my efforts to understand what such a call might mean. Throughout my seminary experience, my pastor neither pushed, nor coddled me. When I shared my experiences, he seemed to understand, but he never denied that ministry was going to be a challenging and difficult journey.

I dedicated the summer before I started seminary to further discern my call, working as assistant cook for the region's church camp. Each week, active pastors came in to volunteer, leading various age-level camps. I had the opportunity to meet all kinds of pastors with different styles, personalities, and theological views.

I wrote to seminaries to request information about their programs and continued to discern what God wanted me to do. I spent time alone with God there, pondering what the future might be. I felt a driving sense that God wanted me to further my learning and equip myself to serve in the kind of ministry where I received my call—as a youth leader. I remember spending a long afternoon with the region's camp director, himself a minister, mentor, and fellow church member. It was never my intent to leave home, my church, or the support of my family and friends.

It felt like something larger than my plans, thoughts, or intentions was at work in me.

If I did not have that strong feeling of my life being "aligned" when following the call, I would have readily left ministry. I even tried more than once, but whenever I tried to leave, the ministry "found me." In other (secular) jobs, it always seemed as if something was missing. I've been at it for over thirty years. As a single woman, I have supported myself in ministry, with the help of family. I have held other jobs in order to do ministry. I have in each case followed a call which, though constant, has held many surprising turns and directions.

I never anticipated being a pastor when I started. I went to seminary to become a better youth minister. Shortly into school, I changed majors from the two-year Master of Christian Education program to a three-year Master of Divinity degree because I felt that would maximize options of finding placement. Since the school's literature stated they placed 98 percent of their graduates, I felt certain that I would have a chance of finding employment when I graduated. Surprise!

I entered seminary not knowing how unusual it was going to be for me, being female. In the late 60s and early 70s, my church had a woman associate pastor, so I didn't know it was that different. I was also surprised when a fellow student questioned my call on the basis of gender. It was surprising to be one of only two women in a class of nearly thirty. These surprises were often not happy ones. I've told people that I learned to swear in seminary! It was also a time of upheaval in the church: inclusive language, feminist theology, liberation theologies.

About the time I graduated from seminary, the denomination, American Baptist Churches USA, commissioned a study called the Study of Women in Ministry (SWIM) Report. This report outlined what most of us had already experienced: resistance, discrimination, discouragement for women in a traditionally male-dominated or exclusively male-led profession. Much of that resistance actually came from women.

Upon graduating, I had only one interview, and it did not yield a position. My first job out of seminary was on the maintenance staff of the school, cleaning student apartments for the coming year. This was a

job where female students were appreciated—we did a much better job of cleaning than the guys!

Shortly after this I was able to get a full-time job and continued part-time as youth minister in a church where I had started as a student. After serious surgery for a ruptured and perforated appendix and a related bipolar episode in the hospital, I lost the job at the church. The devastation was brutal. Although I still had a full-time job, my ministry was shattered. I was shattered. The only thing that really mattered was taken away, with no more than a letter signed by a committee. Misunderstanding, stigma, and fear led to that abrupt, impersonal letter of dismissal. Months later, I was able to reconcile with these folks, forgive, teach them, and move on. If the call had not been so strong and compelling, this would certainly have been one time where I would have opted out and done something more practical.

Desiring to be closer to family in 1981, I interviewed for two positions in my hometown. I did not get the full-time job, but I was quite certain that the part-time church position with a very approachable and straightforward senior pastor would be a good fit. Something significant happened in that one-hour meeting with my future mentor, colleague, and friend. Because he was so down to earth, human, and never took himself too seriously, I could tell in just that amount of time that we would be able to work very well together. And so we did for several years. I was the youth and Christian education minister on a staff of three professionals. The church was a good place to learn firsthand about all aspects of ministry: the "glamorous and the mundane." I learned the realities, the inevitable situations where there are disagreements, the different behavior patterns of church leaders, and so on. I still felt that ministry was the way I would be spending my life. Although there were discouragements, the satisfaction of helping others in faith development and education was gratifying.

The denomination had rules defining ordainable ministry as twenty hours or more, so I asked to increase my hours (decreasing the hourly wage), in order to be eligible. Many women were caught in the Catch-22 situation of feeling and living God's call, but not finding "ordainable

settings" or not getting church employment because they were not ordained! God's call was still tugging at my heart. It seemed to be compelling me to move toward ordination, even though several persons were saying no. An interruption occurred when my father died. I had to be treated again for a bipolar episode immediately following his passing. This was a setback for me. I had been hoping to be ordained in his lifetime. He was the one who brought me my Baptist roots. He was an active churchman and deacon. It was not to be, not in that timing at any rate.

I continued in secular employment. In time, I served by leading a children's ministry for the Chinese Church. This experience was an affirmation that my call was still active, and that I could be part of a cross-cultural ministry within this small church. When congregations respond in positive ways to what is happening and the pastor and lay leaders are pleased, this is a way of confirming the call, in my understanding. It doesn't always happen, but when it does, it makes work a joy.

My first full-time ministry job came seven years after graduating from seminary. That was a long time to wait, but it was like a dream come true. I became the adult services coordinator at Milwaukee Christian Center; a home missionary, commissioned by the Board of National Ministries of American Baptist Churches USA. I had hoped for that position for years. As a missionary, I served on behalf of the whole church, ministering among low-income people and culturally diverse populations. I was also part of a national team called NAP, the Neighborhood Action Program of the Board of National Ministries. In this association, I was treated as a colleague and fellow servant. This connection helped me become more specific and focused about the call.

About halfway through my time at the center, I sought ordination for at least the third time. I'd been turned down for different reasons. The first time, it was mostly because of gender. The second time, I was told my knowledge was lacking. After being offered support and assistance by two colleagues, as well as a retired seminary professor, my paper and the defense of it seemed to be adequate.

The third effort was nearly thwarted as well. The question came up as to whether Christian center work was "ordainable." In other words, was

this "real" ministry? Ironically, I received a phone call advising me of this concern from the Commission on Ministry (the regional clearinghouse for ordination council work) while I was in the county hospital with the husband of one of my group members from the center. The woman had just attempted suicide, and I was the one they called for help. My ministry was being viewed as "less than" or insufficient somehow, exactly when I was providing life-giving ministry to one of my families.

After considerable time at the center, it seemed like a move was imminent. I sensed that a move to church planting in an urban setting might build on skills and experiences I had. With help from NAP colleagues, I moved to Kansas City to work with a church re-start, probably the most difficult type of new church work. I moved down there, learned the community, and led two summer programs for children in the immediate area, in the hope of finding a nucleus of completely unchurched folks to start a church. The plan was to eventually join our new group of about twenty unchurched families to the aging members of the original congregation. After just six months of worship, the region decided that our group could not be continued. Closing Peoples Church was perhaps the greatest grief I have ever known. I was granted up to six months severance assistance to find a new ministry. At the time, the average length of time for placing a woman in ministry in the denomination was two and a half years! Nearly fifteen years after the SWIM report came out, the problems persisted. There were times when being a pioneer was definitely not a blessing.

Within months, I heard from a church in South Dakota. I became the only female senior pastor in the region, which included both Dakotas. Among the parishioners was a woman who, for the entire three years I pastored there, spoke to me only twice. She was against the idea of women in ministry, and her silence spoke to her disapproval. She had asked me during the interview weekend how I knew God had called me to ministry. After several minutes of listening to me explain my journey, her reply was, "So, it was just a feeling then?" and she left the meeting.

While the empirical evidence of a call is very difficult to define or explain, I believe signs such as certain events coming together, prayers that

are inexplicably answered, and understanding events after they happen, helped determine God's working in my life. Once, I had given three months' notice on my apartment. The third month was exactly when my new position, which included a parsonage, opened up. Mentors, colleagues, family, and friends have helped me see God's path when my own eyes could not. I was in a prayer group consisting of three women who met weekly for about eight years. I'm certain they prayed me into the position at the Christian Center. When I was finally ordained, those two women had to be part of the service!

In 1998, after a residency in chaplaincy training, I had two choices of where to minister at the same time—the only time in my thirty-three years since seminary that I've had this experience. Two full-time possibilities of where to use my gifts and graces serving God in Southeastern Wisconsin! This was quite a turn of events. I chose the nursing home chaplaincy, and then served a bedroom community parish for the United Methodist Churches.

I am now serving two rural parishes, which together is still half-time employment, and still trying to find other employment that can support me, while leaving enough time to serve these small parishes. I find that the gentle folk in these churches have been a good match for my gifts and graces. I have a lovely parsonage in the midst of much green space, and I am close to the interstate and "civilization." I can find something to be thankful for in each day.

In ministry, I've often said that I never dreamed of being rich, and I've certainly exceeded expectations. I've learned that there are many things in life more important than money and I have adjusted my needs to match the income I currently earn.

As I look back over many fruitful years of serving, I think the best days were the ones where I could make a difference in the lives of those I served: a day of moving furniture, bedside visits, assisting with basic needs, weddings, funerals, baptizing twin children of a Vietnamese war orphan, caring for the lost and lonely, preparing youth for church membership. I've had lots of incredible experiences within the ministry itself: talking theology with girls, youth, and regular folks, planning worship in a

variety of settings for diverse groups, group outings, one-to-one conversations about faith and life.

I find, when I do a bit of looking back, that I have had an impact on many lives, and I am thankful for the call as much as I have understood it, which has kept me moving forward. I am a mentor and encourager to younger clergy, especially women, who do their best to follow God's call. I echo the hymn writer, H.G. Spafford, who claimed, "It is well with my soul."

At my ordination, a beloved colleague and friend stated, "Bonnie, this is just the beginning," and he was so right. God's call has led me to amazing places and extraordinary people. During that ordination service, another colleague sang a hymn from the African American tradition, which also speaks to my experience of call:

"I don't feel no 'ways tired;

I've come too far from where I started from.

Nobody told me the road would be easy,

I don't believe (God) brought me this far to leave me."

The call persists, surprises, baffles, and delights. It comforts and constrains. I am thankful, and I believe I have been faithful. Thanks be to God!

Rev. Bonnie Bell graduated from Northern Baptist Theological Seminary in Lombard, Illinois, in 1979 and was ordained in 1989 in Milwaukee, Wisconsin. She has served churches and ministry settings in Illinois, Wisconsin, Kansas, and South Dakota. She currently resides in Concord, Wisconsin, and is pastor to two small parishes.

Kathy Helms

What is it that makes my experience unique to most pastors? I am an oxymoron. I have served as a woman called in Baptist life over the past eleven years. A woman called and being Baptist is kind of like mixing water and oil. "Called?" you might ask. I *must* be because I am not sure who would purposefully stand in such a difficult place. Called to what? Ah! Now that is worthy of a discussion that is exciting and dynamic.

My observation is that things are much easier for my male counterparts. Male pastors do not have to make a choice about whether to be ordained or not in order to ensure their ministry opportunities. I struggled for three years about whether or not to be ordained. I kept hearing the words of a male colleague who told me I shouldn't because if I did, it would close many opportunities for me to serve in Baptist life. I hesitated because I knew there was truth to what he was saying. But I needed to come to a place where I had to either embrace God's call on my life or continue to deny it. I could handle other people denying what God was directing me to do; I just couldn't live with denying my Lord. So I took the plunge! In 2004, I received my ordination from Hatcher Memorial Baptist Church of Richmond, Virginia.

One would think that embracing my call would be a walk on the beach. Far from it! But it has been the one monumental decision of truth in my life that has strengthened my faith and given me the power to stay true to myself and my God. When you are willing to say yes, to stand where Christ wants you to stand, you must count the cost. That is

one way to know that you are doing what God has called you to do. Be prepared to stand alone if needed. Did I lose friends? A resounding yes! Whoever thought that when I chose to dive into the ministry, so many in the "pool" would either scramble to get out or create circumstances to make me want to climb out of the "pool" as if I didn't belong there in the first place. I had one conversation with a friend who said to me, "What do you mean you are ordained? I thought only men could be ordained. What does it mean for *you* to be ordained?" As if it meant something totally different just because I was female. My friend proceeded to tell me that because of my ordination our friendship would have to end. I told her all I knew was that to deny my call would be to deny what God was telling me to do in my life, and I would be denying God to not choose ordination. This was probably the first wave that came crashing down on me by accepting God's call on my life. Do I regret it? No way! To embrace the truth of who I am and who God has made me to be—no matter how others define me—is to experience the deepest, most satisfying wholeness and joy for my life.

Speaking of definitions, I am able to look with hindsight on what calling has actually meant over the years. Within Baptist life, calling was always defined for you. It was defined in books on Baptist polity, as well as by the denomination and the local church. I was taught—and perhaps to some extent indoctrinated to the idea—that calling was something that was experienced personally but was also something that was recognized communally through the body of believers. I believed this for many years but I am just now waking up to a theological shift in my perspective and praxis of understanding. By putting calling into the conformity of the institution, the definition of it was distorted for me because I was Baptist and a woman. I had a hard time dealing with a seminary experience that highly celebrated and supported my calling while the chance of that call being celebrated or even recognized by the local church was slim to none. I was even stripped of my title of "Reverend" many times in the printing of the weekly bulletin so as to not threaten or show any equality with the lead pastor. These actions that reflected attitudes of stripping away acknowledgement, lack of mentoring, or ministry opportunities made

me question my "calling" to the local Baptist institution. Upon accepting staff positions at several churches, the inevitable question was asked, "Do you feel called to serve our church?" When I used to formulate my understanding of my calling around this question of conformity, I would compliantly answer, "Yes." But I now would answer, "No!" because I have spiritually grown to have a different understanding of what calling truly is. The Holy Spirit, who is at work in my life and who is responsible for my growth, has brought me to a place of knowing my call in the context of transformation. I am convinced that experiencing transformation is part of God's intentional work for my life. One of these areas is how I have come to define and experience calling. I have decided not to settle for an oxymoron.

The changes that have taken place for me are many and all for good. In my years of ministry, I have just recently hung up my hat as a music minister and put on a pastoral one. I decided to believe in who God had made me to be and who God has truly called me to be as recognized by those around me. In fact, when I shared with my family the decision to be a practicing pastor and start a new faith community, their response was, "What took you so long?!" I now serve as lead pastor of MPACT Faith Community, which meets the needs of college-age students and challenges them to actively be transformative through community missions.

What I have experienced has a lot to do with letting go of definitions of calling that have been confining my life and grabbing onto that small, still voice inside and learning to trust it! These are the best words of affirmation that I can give you if you are questioning whether or not God is calling you. God put that voice in you in the first place. Act on faith with what God has shown you to be true for your life. Do not base your decision on man-made definitions of what it should be. It takes guts, determination, and sheer will to choose the road less taken. Are you a woman called? If you are asking the question, then the answer is yes! I would challenge you to ask yourself what you are called to. Are you called to the local church, or are you called to God? How do you define calling? Is it what other people have defined for you, or is it defined by who God has made you to be?

I enjoyed being Baptist. Unfortunately, I am using past tense. Within the Baptist context I was told on more than one occasion, "You are not a good fit," which made me believe in a way of thinking that promoted the idea that I didn't have any choices. This is the cost of a woman in ministry staying in a place that never quite creates an atmosphere of spiritual growth, honesty, and reaching one's full potential.

I do have choices! They are choices I never envisioned I would have to make. They are choices that God had already made for me. I just needed to decide whether or not I would participate in them. God's will for my life includes choosing the pastorate, starting a faith community, and not being affiliated with a denomination. Because of these choices, I can now say serving in ministry is like a walk on the beach in all of its truest forms of enjoyment and beauty! This is the hope on the journey. It's the "no's" in my life that created the "yes" moments. I used to feel threatened by the rejection that comes with not fitting in and yet God said, "Don't worry about it, Kathy. I have a place for you, and it's better than anything you could ever imagine! All I need you to do is dive in."

Calling. What a funny word! Like most words, context is everything. Usually seminary education, denominational context, and religious tradition teach the meaning words hold in our lives. As a woman in ministry and raised in Baptist life, I consider this word a dynamic one at this point. Its meaning has continued to change for me. The closest I can get to its truest essence and my understanding of it for my life is to say that calling is like diving into a pool. It would be so easy to use this analogy to talk about sinking or swimming. It could serve as an education tool on learning how to swim. These are the usual analogies that already come to mind and have probably been used before. I could also talk in terms of sinking or swimming when it comes to Baptist life or being a woman called, but I really want to have a discussion about something else that God is showing me.

When I speak of diving into the pool, I am talking in terms of warm, relaxing, pool water being symbolic of the Holy Spirit and God's work in the world. I bring this up because this paradigm totally changes how I define my call and what I am called to. I used to feel I was called to Baptist

life or called to a particular church. These roles put me in a position of maintaining the "pool" or having to figure out how to keep my "pool" membership. By staying in these places, I never really experienced the pure ecstasy of diving in. True calling for me has been letting go of those "lifeguard" places in ministry where people's expectations positioned me as the one who sat outside of the water trying to keep everyone safe and following the rules. Sitting on the side of the pool, I never really fit in and from that vantage point was told many times I needed freedom from certain aspects of my theological understanding. My creative God had one thing to say to me in response to what everyone else had defined calling to be. God contradicted it all and said, "Dive in!" This is where true calling is experienced. Feeling the "deep water" of the Holy Spirit envelope me, surround me, and embrace me. This only happened when I was willing to dive in and realize that maybe the conversation isn't about what I need freedom from in my life, but, in Christ, who I have the freedom to be. This is what diving in has taught me—freedom to be who God has made me to be. This is where God's calling on my life has led me. All God calls me to is taking the plunge and being immersed in the soothing, peaceful water of God's Spirit. This is my calling! God does not expect me to hold onto the water once I'm there. If anything, I can only hold a small part of the water in my cupped hands. God truly is the holder of it all! If I try to grab onto the water, it is nearly impossible, and yet I'm immersed in it. I know it's there because I feel it, and I see it all around me. God is teaching me that calling is God's work, not mine—or the church's work for that matter. Ministry is about what God is already doing and me joining God in it. God is calling all of us to "Dive in!"

Rev. Kathy Helms is working on her Doctor of Ministry degree at Central Baptist Theological Seminary. She is a native of Virginia and received her Master of Divinity degree from Baptist Theological Seminary of Richmond. She is pastor and founder of MPACT Faith Community (www.mpactchurch. org), which focuses on college students being transformative through local community missions. She lives in Overland Park, Kansas, with her husband and four adult children.

Rosanne Osborne

Growing up in the small towns and farms of Missouri, I learned the importance of hands. Hands may have been more important than heads and perhaps even hearts. What a person thought or felt was not so important as what he or she could do.

I look at my hands—blunt fingers, short and stubby, slightly arthritic, certainly wrinkled. My little finger is shaped exactly as was my mother's, my index finger is strikingly close to the shape of my father's, and my thumb is that of my maternal grandmother.

My father taught me to use my hands to massage the udder of a cow before I began to milk. My mother taught me to shape the mound of dirt before spacing pumpkin seeds in the hill, and my grandmother taught me to prime the pump to raise the water from her well.

I watched my father raise his 22-rifle, and draw a bead on a defenseless rabbit darkened against the whiteness of a snowy day. I watched my mother hold the head of a fryer on the chopping block and raise the hatchet to take the life of that young chicken and send his pieces to the frying pan. I watched my grandmother rip wool pants into strips to be woven into rugs, to rip out seams I had carelessly sewn.

I studied their hands and I saw what they shaped, what they created, and what they destroyed. I learned early on that what I did with my hands would clearly show the dimensions of my life. I grew up believing that action was the key to the substance of a person. Work defined a person's character and gave dignity.

It was only when I retired from a long career as an English professor in a Baptist college that this life philosophy was called into question. Sure, I had time to clean my house, mow my lawn, and plant flowers, but those were the ordinary tasks of maintenance that gave me little sense of purpose. Purpose—that was what was missing. In the months following retirement, I found my health deteriorating, my energy flagging, and my time taken up with watching way too much daytime television. Fortunately, a medical crisis forced me to reexamine my priorities. The words of the writer of Ecclesiastes rang in my ears: "Whatsoever thy hand findeth to do, do it with thy might for there is no work, nor device, nor knowledge, nor wisdom in the grave, whither thou goes." I wanted to live, and I realized I wanted to live abundantly.

To regain strength, I returned to the pool and water aerobics. I'd never learned to swim as a child, and thus I had a deep-seated fear of the water. As long as I stayed in the shallow end of the pool, I felt safe and secure, but somehow that was boring. I wanted more. I began to wonder whether I might learn to swim. Fortunately, I found someone who was willing to try to teach me. Thus began a life-changing experience for me.

Each morning for one entire summer, I met my instructor at six and struggled to face my fears and overcome them. It wasn't pretty. First, I could not trust myself to float or to swim more than a few short strokes to the edge in the pool in water shallow enough for me easily to stand. The first day that my coach convinced me to swim beyond the four-foot mark was a terrifying experience. As I saw the lines at the bottom of the pool move downward, I was certain that I was going to meet them at the bottom of the pool before I got to the other end. Yet the first time I swam the entire length of the pool, I felt a level of exhilaration and accomplishment that I hadn't felt in a long time. And the first time I actually jumped into the deep end of the pool erased all of those old barriers. As I acquired skills, I found myself growing physically stronger and more confident in my ability to accomplish new goals. My health improved, but more importantly, I began to believe that age was not a limiter in exploring new patterns for living.

In a strange way, learning to swim prepared me for what at the time seemed an astounding notion. When I had gone to Israel in 2000, I had bought a t-shirt with the Hebrew alphabet illustrated by camels doing cartoon-like things. The t-shirt was a Hebrew alphabet book—a camel resting on bet, a camel kicking a soccer ball through kof, and a camel smelling daisies through tav—camels cavorting through all the letters of the Hebrew Scriptures. Obviously, this wasn't anything I was going to wear in public, but it had caught my fancy, so I often slept in it. One morning while brushing my teeth, the camels winked at me in the mirror, and a new idea popped into my head. Why don't I go to seminary and learn Hebrew, I thought. That seemed nearly as absurd as wearing the t-shirt to Walmart, but the idea persisted. I began to realize that God was using a t-shirt to get my attention, to call me to a task I had never contemplated.

That fall I entered New Orleans Baptist Theological Seminary to pursue a Master of Divinity degree in biblical languages. The day I went to enroll at the central Louisiana center, I noticed that two of my class-mates would be students I had taught and that everyone would be at least half my age, some three-quarters. They had no idea how intimi-dated I was. I wasn't at all certain that I could bend my failing short-term memory around the tasks of learning Greek and Hebrew or of taking tests in other subjects. Frankly, my first exam in Hebrew was a disaster. I found that I had to work much harder and review vocabulary much more often than the younger minds that had become my peers. New concepts were not as readily accessible as they had been when my mind was more flex-ible. I had an advantage in having taught writing, but I soon realized that even writing papers would take me much longer than it had in the past.

The last semester before graduation, two of my four professors were students I had taught when they were undergraduates at Louisiana College. That raised intimidation to a new level. I had to be certain that I lived up to the quality of work I had demanded of them, but for a teacher to sit under the leadership of former students is a rare and wonderful experience. I could see in them what I had wanted them to be. That expe-rience ranked high on my list of life blessings, an unbelievable affirmation

of what it had meant to me to teach. I went into those classes—Pastoral Ministry and Proclaiming the Bible—like any other student focused mostly on graduation. What I hadn't expected was the change those two young men would bring to my life. When I acknowledged the call to seminary, I saw its purpose to rest primarily in further preparation for the writing I regularly do for Women's Missionary Union (WMU). Somehow, as I studied with these two former students, I began to know that at seventy-five, God was calling me to the ministry. To begin thinking of myself as a minister was as absurd as wearing my Hebrew alphabet t-shirt to the grocery store.

The week after I graduated with five other women among eighty Master of Divinity degree students from a Baptist seminary, I received a call from the minister of First Presbyterian Church just across the river from the town where I live. Would I preach in her church while she was on vacation? My earth stood still, and in that moment I knew beyond any shadow of a doubt that my sense of calling was right on target.

She told me that she had been in the congregation of Emmanuel Baptist Church in Alexandria, Louisiana, when I had preached my first sermon the previous October as part of a class requirement. She was on maternity leave from her church and wanted to hear our young minister. She slipped into the back pew with her six-week-old baby so that she could leave, if necessary. When she looked at the program and saw a woman's name, she said to herself, "Yes, this is right. The first preacher's voice my baby daughter will hear is that of a woman." Of course, that's another absurd notion. I know that the baby not only slept through my sermon but had no understanding that she was hearing a woman preach. The symbolism, however, is gripping.

God's call was not new to me, but my cultural orientation had filtered its intent and purpose when I was a younger woman. After teaching public school in Missouri at mid-century, I had heard a resounding call from God that had sent me to Louisiana and the seminary in New Orleans. I had thought then that I would be a Baptist Student Union (BSU) director. During the years when I pursued a Master in Religious Education degree, I served as a church youth director and later as a BSU director

on a New Orleans campus. Those were the years before youth directors became youth ministers and BSU directors became campus ministers. With that change in nomenclature, gender became a strong counter in Baptist church and denominational appointments. Women were further marginalized. I subsequently accepted the role as college professor in a Baptist college to be God's plan for my life. And, certainly, I think it was, even though I know that the gender ceiling was becoming a hardened fact in Baptist life. While I had looked wistfully at the divinity curriculum when I had entered seminary, I knew then that it was for men who were going to be preachers. Women studied religious education and found other areas of service, and I followed that tradition.

Women's Missionary Union was a haven for me during my college years, and I recognized that the organization provided a safety zone for female leaders to emerge. After four years of college teaching, I became an editor at WMU. The five years I was in Birmingham were fulfilling years, but there lingered in my soul the nagging sense that my ministry must be face-to-face rather than solely print-to-eyes. When the door opened, I returned to college teaching and saw that to be the shape of my calling for the rest of my career.

When I retired from teaching, I thought I might continue to write for WMU, but I had no idea that God might have other things in mind. It occurs to me now that the entire concept of retirement is a secular rather than a sacred idea. I think of Sarah and Elizabeth, women who were used by God to bear significant children at advanced ages, and I reexamine my sense of the absurd. I'm realistic enough to know that no matter how I wish to be called to pastor a Baptist church, that is simply not going to happen. A Presbyterian chaplain friend, who was reared Baptist, reminds me that calling is more important than denomination.

So, while I am certain that no matter how absurd it may seem, I have been called by God to be a minister. With that certainty, I have asked my Baptist church to ordain me. I know that my ministry is going to shape itself in supply work in Methodist and Presbyterian churches. Perhaps, because I was reared in a tradition that marginalized women, I will be content with whatever opportunities come my way. I will, however,

continue to pray that despite my age and gender, I will pastor a small church.

I have a growing certainty that a place of ministry will be placed in my hands and that the experience will be as surprising as all of the other events of the last four years. That Hebrew alphabet t-shirt is practically threadbare. It's time for me to buy a new t-shirt. Perhaps this one will have a clerical collar.

Rosanne Osborne is a retired professor of English from Louisiana College. She received her Master of Divinity in Biblical Languages from New Orleans Baptist Theological Seminary in May 2012, and she is to be ordained by Emmanuel Baptist Church in September 2012. She is currently enrolled in the Ph.D. program in biblical interpretation at NOBTS and is seeking a pastorate in the Methodist Church.

Jenny Frazier Call

"When Pharaoh let the people go, God did not lead them by the way of the land of the Philistines, although that was nearer; for God thought, 'If the people face war, they may change their minds and return to Egypt.' So God led the people by the roundabout way of the wilderness toward the Red Sea" (Exodus 13:17-18).

When I think about my journey of calling, "roundabout" seems an appropriate word. There are elements of surprise and inevitability in my vocation. In some respects, I can see how God has been preparing me for this all my life. But the surprises are found in a journey that has brought me full circle back to my beginning point, much like the prodigal son.

I was born in the small town of Martinsville in southwestern Virginia, in the foothills of the Blue Ridge Mountains. I was blessed with a loving Christian family, and church was a second home to me from the time that I was a baby. Upon my father's death when I was only five years old, the church truly became a surrogate family for me, providing support, guidance, and plenty of positive male role models. I was baptized at the tender age of six, partially due to the influence of my Christian environment and partially out of fear of the hellfire and brimstone sermons that I scarcely understood. I took a leadership role in church early, leading Children's Church when I was still a child, teaching Sunday School, and joining the adult choir as a youth. My family always assumed that I would be a missionary someday, because in my fundamentalist background, this was

what religious women could do. I naturally resisted this classification and spent much time contemplating my future and my escape.

As a serious and studious child, I had my life figured out by third grade. I would be a famous scientist finding cures for disease, a working wife and mother, and a Christian—in that order. For an ordinary girl living in an ordinary place, I desired much. Mostly I wanted to get away from the dullness of home with its memories of struggle and prejudice. I wanted to find my place in the world both literally and metaphorically. By choosing to continue my education, I essentially became an outsider in my home and church. I was the first in my family and one of the first in my church to go to college. My church family could not understand my desire to continue my education—wasn't church and the Bible enough for me? Through the process, I often felt that leaving to further my education was the greatest rebellion that I was capable of.

This journey took me to the College of William and Mary where I was a pre-med science major, studying chemistry and biology with the intention of becoming a medical researcher. Much to my surprise, I disliked the long, isolated hours in the lab. For the first time in my life I was without a plan. I graduated from college and moved to Richmond with some friends and worked at a few menial jobs to pay the bills. But my true joy and passion came in a volunteer job as a youth leader in my church in Williamsburg, where I was commuting an hour one-way several times a week.

I'll never forget the first stirrings of a calling within my heart. I had taken my group of youth to a camp at Liberty University, and we were in the final worship service of the week. I had loved the entire experience—leading Bible studies with my group, talking with several that had questions about the faith, and counseling one girl through her painful memories of sexual abuse. I was praying amidst the chaos of a room crowded with teenagers that God would guide me in the right direction in terms of my career. I remember thinking and praying, "God, I love this so much . . . why can't I do this as a career? And then the still, small voice spoke distinctly from within me, with just a hint of ironic humor, "Well, why can't you?" Why not, indeed? Suddenly, there was peace within me

for the first time in months. I knew that ministry was my calling, and I accepted, blind to the road ahead, but for the first time with peace at the unknown. It's funny to me now at this point in my journey that God could lead me to this decision at Liberty, a place that would not accept me as a candidate for ministry! Thankfully, God and I both have a sense of humor!

I entered Baptist Theological Seminary at Richmond (BTSR) in the fall of 2000. Seminary for me was a community of questions and doubts that helped me to address my own hidden struggles with God and self. Growing up, "just have faith" was the mantra of my family and church, and to have faith meant that you accepted what happened unquestionably as "God's will." It was a freeing experience to be able to work out my own theology (a work in progress) and know that this is acceptable. I also had the opportunity in seminary to discover my gifts in a variety of ministry settings. In exploring different ministry settings, I worked as a youth minister, campus ministry intern, and preschool teacher for at-risk children. I wrote a spirituality curriculum for youth and worked as a spirituality teaching assistant. Throughout these experiences, the common ties have been my passion for youth work, pastoral care, spirituality, and education.

Seminary also helped me to discover my call in another way in finding the love of my life, my husband, John Call. We were married in June of 2002 on the grounds of the seminary that brought us together. In meeting my husband, I found the freedom of being myself and the comfort of having a traveling partner on the journey. I have learned much from him in his pastoral nature, his patience, and his laid-back attitude. He has helped me to further define my theology of pastoral care and ministry in general. He helps me to balance by perfectionist tendencies with his acceptance and his reminders to rest.

Because of the blessing of my husband, I was led to a new transition in my journey. John graduated from seminary in 2003, and when we began searching for our future direction, we were both drawn back to southwestern Virginia. We moved to Roanoke in May of 2003, and I found myself less than an hour from my starting point of Martinsville.

It opened a new chapter of the journey as I began sorting through the tensions that drove me away in the first place.

With the chaos of moving back "home," growing into married life, finishing up school, ordination (and its own trials), starting our first full-time ministry positions, and later becoming parents, the idea of "balance" was key. Unfortunately, we never found it, but through God's grace (and a lot of grace to one another), we learned about sharing our burdens and supporting one another through the rough patches. One of the toughest times was my husband's dismissal from his church position when I was nine months pregnant with our second child. Another was my own burnout after over eight years in my position as chaplain at a group home for at-risk youth. Through these journeys, we've learned how out of control we are in so many areas. Parenthood has provided the greatest examples and areas of growth for me in this.

The true gift for a control freak like me is learning what a blessing it is that I don't need to hold on so tightly or be in control of every move in the game of life. The gift of hindsight is looking back to see the winding paths and understanding the struggles as God's attempts to teach me and strengthen me for what was ahead. Like the Exodus, I can now see how God has guided me through the desert for years (with me whining like the Israelites), only to draw me out into the astonishment of a land flowing with milk and honey.

My latest Canaan land has been my calling as interim chaplain at Hollins University, and it has been a dream come true. Honestly, it is a dream that I gave up on years ago. While in seminary, I did an internship in campus ministry at my alma mater, since the Baptist Student Union at William and Mary had had such a positive impact on my own spiritual formation. But upon graduation, finances were tight and Baptist campus ministry positions were being consolidated and cut. I shelved my dream and was grateful for the other doors God opened. Yet I kept getting nudges in my heart that it would be a blessing to work with and mentor young women. I thought it would be in my job as chaplain and director of Christian education at the Virginia Baptist Children's Home (and I did

get the opportunity to lead a girls' group on multiple occasions), but God had other plans in mind.

It took a visit to Hollins University for my son's preschool play to help me discover again the feelings of "home" that a place can evoke. This was my first visit to campus, and yet, it just clicked. My heart said, "It would be great to work here one day." After I left that day, I couldn't get the place—or the calling—out of my mind. I "friended" the chaplain at the time on Facebook, hoping that she might serve as a mentor to me and point me to opportunities in the future. A week after accepting my friend request, she announced on Facebook that she would be leaving Hollins University (after twenty-four years) for a new calling.

After a moment of awestruck prayers of gratitude, I contacted her, updated my résumé, and sent it to the school the following day. Four months after first feeling at home in the DuPont Chapel of Hollins University, I began ministering there. It has been an amazing journey of learning, building relationships, and being inspired by passion and God-given creativity once again. I now wait to receive word if my contract will be renewed into a permanent position, but I have the assurance in my heart that this is the place to which God has called me to minister, serve, and grow.

God is full of surprises. I used to think I didn't enjoy surprise, but I have to admit I like the ways that God "intrudes" into my well-made plans, wreaks havoc, and then points me to a beautiful new path that I never would have discovered on my own. Sometimes God whispers into my heart, and sometimes God stomps loudly through the circumstances of my life. Sometimes we wander together in the desert, and sometimes we celebrate on the mountaintop. Through it all, I'm learning (slowly, painfully, gracelessly) how to cede control (or at least recognize that I never really had it to begin with). Through the roundabout journey, I've gained strength, and I've learned to look beyond myself. Ironically (or perhaps not, as God is the orchestrator of this), the Hollins University motto is "Levavi Oculos" (I lift up my eyes) from Psalm 121.

Psalm 121
Assurance of God's Protection
A Song of Ascents.

I lift up my eyes to the hills—
 from where will my help come?
My help comes from the Lord,
 who made heaven and earth.

He will not let your foot be moved;
 he who keeps you will not slumber.
He who keeps Israel
 will neither slumber nor sleep.

The Lord is your keeper;
 the Lord is your shade at your right hand.
The sun shall not strike you by day,
 nor the moon by night.

The Lord will keep you from all evil;
 he will keep your life.
The Lord will keep
 your going out and your coming in
from this time on and for evermore.

Rev. Jenny Frazier Call is an ordained Baptist minister serving as an interfaith chaplain at Hollins University in Roanoke, Virginia. A graduate of the College of William and Mary and Baptist Theological Seminary at Richmond, Jenny learns the most from her beloved husband of ten years, John, and her precocious children, Brady (6) and Maryn (4).

Ali Sakas

I first felt a call to be a missionary at Girls in Action (GA) camp at my local Baptist associational camp in Clayton County, Georgia. I had grown up in church, going every time the doors were open—and often even when they weren't—as my mom was our missions director and in charge of putting up all the bulletin boards. Missions was a part of my life at an early age. I think one of the first songs I learned as a youngster was the Girls in Action theme song. So, at the age of eight, I remember sitting in the chapel at GA camp listening to a missionary speaker, probably to the Philippines or some other far off country. I don't remember all of the details, but I remember the altar call in which the camp pastor asked those of us who felt called into Christian service to come down. At the time, I didn't really want to go down because I was so shy. But I knew there was a stirring within me. So, I did what every good Baptist girl did . . . I prayed. Right there in the pew I gave my life over to God to do whatever He wanted with it. I had already given my heart to God, but this was different. This was me saying, "God, if you want me to go to Africa and be poor and live in a hut and eat bugs . . . I'll do it for you!" At the time, that's all I thought I could do. Whether or not that was because of my upbringing in missions or because of my church's view that had ultimately rubbed off on me, I'm not sure.

After my calling at the little Baptist camp, life went back to normal for me. I kind of forgot about that moment until my tenth-grade year. We got a new minister of music at our church, and he and his family had been missionaries to Burkina Faso, West Africa. I was fascinated by their family and quickly became best friends with their daughter. That summer, I went on my first mission trip under the direction of David

Brown to Greenwich, Connecticut, and New York City, where we led Vacation Bible School at a local church. That experience again stirred something within me. I came back from our trip excited about sharing my faith and with a renewed sense of "calling" into ministry. I remember the night we got back to Georgia, my parents took me out to eat. I could not stop talking—something that was very odd for me because I was very quiet at that time. I told my parents that I thought I was going to become a missionary and tell others that Jesus loves them. They looked at me and said, "Yeah, we know. We've been praying for you and felt like God has been calling you."

Again, after this experience, life went back to normal, and I again forgot about my calling. I went to college and was thinking I would get my degree in early childhood education to become an elementary teacher. I did, however, do the "good Baptist thing" and join the Baptist Student Union (BSU), where I was nurtured, loved, and discipled. I was a summer missionary through BSU every summer and was able to go all over the country sharing the love of God with teens and kids. All of these experiences still did not bring me back to my original calling. In my junior year, my BSU director and interns asked me to go on our spring break mission trip to Washington, D.C. I had just had a brain shunt placed in my head, so I was a little skeptical about going on a trip—I was a little embarrassed because I had no hair. But they kept on insisting, so I signed up. At this point in my life, I was very scared of everything; especially people . . . especially scary homeless or criminal people. We worked at a Baptist center in Washington, D.C. and worked with the homeless, giving them food and just seeing them as people. We also went to a juvenile delinquent center. This was the most eye-opening experience I have ever had and completely changed my heart and life forever. On our van ride to the center, I was so scared and nervous, not knowing what was in store for me. I mean, these kids were locked up because they had done horrible things. They could do horrible things to me and probably would, for all I knew! When we got to the center, we were split into two groups based on gender. I have no idea how or why I was put with the males . . . my name is often confused with the male Ali and I had no hair, but still . . .

So, I got to visit with the male inmates who had not seen a female in a very long time. I was not much older than they were, and man, were they excited to see me. I had never heard such crude words! I had come in with so many guards up, and when they spoke to me, I thought my reaction would be to retreat into myself or hide behind my fellow students. But it wasn't! Instead, I looked into these young men's eyes and really saw them. I saw them as helpless, hopeless, scared little kids who had not been taught right from wrong and who had not been loved as I had been. I was no longer scared of them, but was sad and hurt for them. I wanted them to know that God loved them and forgave them. I wanted them to know that they could change their lives around, and they didn't have to be "criminals" forever. After this trip, I began praying for God to send someone to these boys to tell them that someone loves them and cares about them. As I prayed, God began saying to me, "Ali, why don't you go, why don't you tell them?" I had every excuse in the book, "Ummmm . . . God have you seen me?! I'm only four-feet-ten-inches tall; they could overtake me easily. Ummm....God, I'm REAL white!!! I have NOTHING to give them. I can't relate to them. I have nothing to share with them." And as I brought my concerns to God, He quickly reminded me that I have love and I have His message of love and grace, and that's all that's needed.

When I told my parents that I thought God was calling me to work in an inner-city setting with troubled teens, maybe helping kids who are in gangs to get out and start new lives, they looked at me and said, "Are you sure? You do know that in order to do that you have to go into some scary places, and Ali, you're scared of your own shadow. You can't come into a place without every light being on. You are scared of people you know, and you don't really ever talk. If this is what God has called you to, then we will support you, but just know that you'll have to change."

I heard all that my parents said, and believed every word of it because I was a very nervous and scared little girl for most of my life. My biological father had walked out of our family when I was four years old, and I had some trust issues because of that. I had also gone through some hard things as a young kid, so I was nervous that someone was "out to get me" all the time. I basically did not trust or like anyone accept my mom, most

of the time my stepdad, and sometimes my sister and my new friends from college.

I know after I told my parents this news they immediately started praying for me. They probably were praying that God would reveal the truth to me . . . that I was NOT called into inner-city ministry, because clearly I was not "cut out" for it. But I also began to pray for God to change me. I started meeting with my college intern, Michelle, and she started mentoring me a little bit. We did a Bible study together over the book of 1 John. One night after our meeting I came home and made a sign for my dorm room door that said, "Love God = Love People." Up until this point I had the loving God part down. I was totally committed to whatever and wherever He took me, but I had a hard time with people. People are cruel. People are not dependable. People will hurt you. But I'm a person, and God loves me, and God loves every person. If I say that I'm a follower of God, then I better start living like Him, which means I have to love people. I put that sign on my door so I would see it as I went out, giving myself a reminder that I have to love people. At first loving people just simply meant accepting people as who they are, people that God loves. I had to pray to start seeing people as God saw them—His beloved children. All I could see at first was their potential to harm me or to disappoint me. But slowly I began to see that not all people were harmful, and that, in fact, there were some fabulous people! And over time I also began to see even those people who did harm me and who could harm or disappoint me still needed to be loved—and to be loved by me even.

So, I changed my major to criminology since it was at a juvenile delinquent center that my life was changed. I figured, what better way to give back than to change other people's lives at a juvenile delinquent center. I thought I would become a juvenile probation officer, but there was still this thought about my call to be a missionary in the back of my head and heart. Could I be a missionary as a probation officer? Would I still be honoring my call if this became my career? I think the answer is a resounding yes—we are missionaries not because of our job title, but because God has called us to proclaim His love and salvation to the ends

of the earth. This means in Africa and Asia, but it also means in a jail cell, in a classroom, and in an office cubicle.

I did not end up becoming a probation officer. After graduation I pursued a Master of Arts in Ministry-Based Evangelism from Southwestern Baptist Theological Seminary (basically a Biblical Social Work Degree). I still had a sense of calling specifically into the ministry. I knew that God had specifically called me to be a missionary, so I had to pursue what He had called me to. I went to Southwestern because, as a Southern Baptist, this was THE seminary to go to. I am so grateful I did . . . not so much for the classes or the professors, but because of the experience and the amazing people I met—people that I would partner with in ministry later. All of my professors were men, not that this is a bad thing, it's just an observation I had. I knew that there were some classes that I couldn't take because I am female (preaching and pastoral classes). At the time it didn't bother me because I wasn't looking to be a pastor or preach ever, so it really didn't concern me. The president of the seminary when I first attended was Ken Hemphill. He was a very personable, caring, and compassionate leader from what I knew of him. I would see him often as I went to the student center to check my mail. He would be eating lunch with other students at the café. I had also heard of him working out with students at the Recreation and Aerobics Center (RAC). And anytime I would pass him on the campus he would always smile and wave. However, at the end of my first year at Southwestern, Dr. Hemphill was asked to resign. The students had heard a rumor that it was because he was too liberal and the seminary wanted to restructure.

I had specifically chosen Southwestern because it was THE seminary to go to, but also because it was a little bit more liberal, allowing women to go there and having a view that all people (men and women) are called to minister to all people. I knew that Southeastern Baptist Theological Seminary in North Carolina was very conservative and did not have such a positive view of women in the ministry. Paige Patterson was the president there, and from what I knew of him, he had a very conservative view of women. After hearing that Dr. Hemphill resigned his position, the students held a prayer vigil in which we prayed for our new president.

We were told that no one had been hired for the position and that the students would have a voice. We had all heard rumors that Paige Patterson was going to be the new president, and a lot of the female students were outraged. I remember saying to one of my friends, "If he comes, I'm leaving."

Well, Dr. Patterson came, but I stayed. I reasoned that I was not going to let a man run me off. Really, it was because God had placed me there for a reason and, in all honesty, what else was I going to do? With new leadership came a lot of changes.

For the first time in my life I was confronted with the idea that as a woman I did not belong in the ministry. This was not told outright to me, but I felt it. I knew that Dr. Patterson's view of women was that they should be seen and not heard. I got firsthand experience of this when I passed him on the sidewalk and said hello to him, and he did not speak back. At first I thought maybe he didn't hear me, so I said again in a louder voice, "Good afternoon, Dr. Patterson," but still there was no response. I was the resident advisor in the women's dorm, so I had the opportunity to hold forums and discussion groups that were pertinent to the women in my dorm. The residents decided it would be nice to hear straight from Dr. Patterson his view of women, since most of what we knew was all hearsay. So, I invited him to the dorm meeting so we could have a discussion. But he did not show up. He sent his wife instead. The next day at chapel, his sermon was on how valuable women are as help mates using Genesis 1–2 and talking about creation and how we are made from and for Adam.

Despite the seminary's view on this issue, I still had a very good experience. While in seminary I worked at Mission Arlington. Their slogan is "bringing church to the people." At the time, Mission Arlington had over 250 house churches that met in low-income housing projects throughout the city. I led four of these house churches. I learned a lot about ministry from this place. Mrs. Tillie Burgin is the CEO of this amazingly unique ministry. She started it after returning from the mission field in Korea when her son got very sick. All she knew was missions, so she started her own mission, helping people who have physical needs, but ultimately

have spiritual needs. As I watched Mrs. Tillie and other women in this particular ministry serving all people, I knew that one man's opinion about women did not dictate what God ordains. I knew that my time at Mission Arlington was only for a short while. My heart's desire—a desire God placed there—was to work with gangs at a Baptist center, preferably in Chicago. I have no idea why I thought this. I had never been to Chicago or worked with gangs.

All I can say is that God placed that desire there. Little did I know all that God had, and still has, in store for me. When I graduated from seminary, I applied to be a US/C2 collegiate missionary with the North American Mission Board (NAMB) through the Southern Baptist Convention. I was accepted; however, there was not a position to which I felt called. After the interview process we were supposed to select a mission site, so I asked what I was supposed to do. They told me to write my own position; to write what my dream job would be. So, I wrote that I wanted to work with low-income families at a Baptist center in inner-city Chicago. I wanted to help young people in gangs to have an avenue out. The NAMB got me in contact with Sandy Wisdom-Martin from the Illinois Baptist Convention who told me there was not a Baptist center in Chicago. She asked if I would consider going to East Saint Louis. I said, "Well, is it in Illinois?" She said, "Yes, it is." So I said, "Well then yes, I will come."

Within a few weeks I had an interview at the Christian Activity Center, an after-school community center for kids ages six to eighteen. Shortly after my interview, I packed up a U-Haul truck with all my belongings to move to East Saint Louis, Illinois, for two years. It's been over six years since I moved here. I never made it to Chicago, but if I had never looked for a position in Chicago, I never would have found East Saint Louis. I had never heard of this city. I used to say that God called me here, now I would have to say that God placed me here. Not because of what I could bring to the city or the people, but because of what they have given me. I thought I would come here and offer grace and salvation to a city with no hope, but what I have learned instead is humility. I have been given grace over and over again by my new family and community.

My heart and life have been forever changed. I have been uprooted and replanted at the Christian Activity Center in East Saint Louis, Illinois, a place of hope and love for a broken community and broken people like me!

I am so grateful for parents who instilled in me that I could be whoever and whatever I wanted to be and who supported me no matter what. I am grateful for college ministers at the BSU who loved me where I was, but helped me to grow and change and challenged me to be a better person. I'm grateful for people like Paige Patterson, who made me challenge and question my beliefs about who I am in the eyes of God. And I'm grateful for other women who have gone before me and taught me by their faithful and loving example of serving others. Without these experiences and people, I would not be the woman or minister I am today.

Ali Sakas is the Kids 4 Christ Director at the Christian Activity Center in East Saint Louis, Illinois. She is from Atlanta, Georgia, and has her Bachelor of Science in Criminology from State University of West Georgia and a Master of Arts in Ministry-Based Evangelism from Southwestern Baptist Theological Seminary.

Elizabeth Evans Hagan

Brennan Manning describes calling this way: "We are made for that which is too big for us. We are made for God and nothing less will ever satisfy us." Even at a very young age, I felt this sense of calling of a holy purpose for my life, though without a framework to even imagine living it out. Regardless, God has pursued me, instructed me, sent friends and colleagues to guide me, and loved me into the exact place where God long ago prepared for me to be. But, piece by piece, the Spirit has always given me direction for what is next. My calling has been to simply follow.

Truly, I've been Baptist since birth. I was conceived while my dad studied at Southern Baptist Seminary in Louisville and born at Baptist Hospital in Nashville. After coming home from the hospital, we lived in the small town of my dad's first pastorate, Orlinda Baptist Church, in Orlinda, Tennessee. While growing up as a preacher's kid (PK) had its challenges, I received incredible gifts of Christian formation through my parents' commitment to the church. Orlinda was a great place to begin my first seven years of life. It was there I first learned about community—what it meant to belong to a group with purpose in the world. Our neighbors were like family to us and also church leaders. Church, for me, existed as a safe and loving haven to feel special. While I rested in the security of belonging to a specific family (that everyone seemed to know), I simultaneously developed an independent spirit which carried me outside of the protective wings of my parents. My mom loves to recount how I began ordering my own food at McDonald's when I was three years old

to relay how I have always been a person with the drive to discover all that life has to offer me, even if I must do so alone. Later this pioneering spirit would serve me well.

Our family made a huge transition from country living to suburban life when I was eight years old, moving to the "big" city of Chattanooga, Tennessee because of my dad's call to serve Memorial Baptist Church. Through participation in Girls in Action and Acteens, weekly mission learning groups for girls and teenagers, my interest in missions around the world heightened. Through summer camping experiences to Camp Carson in Newport, Tennessee, I eventually came to know of God's desire to be in close relationship with me, having nothing to do with the identity of my parents. I could have easily been one of those PKs who wanted to have nothing to do with the church or traditions of my family, but church was more than something our family did. It was my life—and how I personally connected to God. Because of a conflict that was staged in the public junior high that I was to attend, my parents transferred me out of public schools in seventh grade and into Chattanooga Christian, where I eventually graduated from high school. There, through the required Bible courses, I received the spiritual formation that my church's educational program lacked and that I desperately needed. In seventh and eighth grades, I had a Bible teacher who pushed me to begin reading scripture for myself—in fact, challenging me to read the Bible through in one year. Even growing up in a pastor's home, reading the Bible was nothing I ever did personally. I met Mr. Irwin's challenge by reading the Bible through both of those years. Through reading what the Bible actually said, rather than what I was told it said, my eyes began to open. What if God wanted someone like me to serve? According to scripture, it seemed it wasn't out of the question.

Out of such a context, one climactic moment in my life came the summer before I entered ninth grade. During a church picnic, I found myself sitting at the table of one of the visiting guests to our church that weekend. Nena, who was the grown daughter of the minister of music at our church, was soon to be commissioned for a mission position in the Caribbean. After more red punch than either of us should have consumed

in one sitting, I found myself with a new friend. I asked her all sorts of questions about how she was called to ministry. Something stirred within me with each answer she gave. The next day, at her commissioning service, the Spirit brought me clarity about what to do next. Everything from the handbell rendition of "People Need the Lord," to my father's sermon (which I usually thought was boring), seemed to speak a word of God directly to me, so that at the end of the service, I took my father's hand and articulated a call to "full-time Christian service," as Baptists like to phrase it for women. My father's first words were "home or foreign missions?" I, of course, picked "foreign" because it sounded more interesting. At least I'd get to travel!

Let me say, in retrospect, how I affirm the goodness of God's timing in my calling, but to say that such a calling was "good" was nowhere close to how I felt at age fourteen. Isolation and loneliness became guiding feelings throughout my high school years—for in a conservative church, a young woman with a passion for God was definitely a perplexing thing. Thus, confusion set in as I tried to understand what God was doing in my life, and my church was even more clueless. Every time our youth group came home from a trip, I was asked to speak and I found much joy in sharing myself in sermon form with others. But, while the boys called to ministry were licensed and affirmed, church members just patted me on the back and told me I was "cute." I remember recounting to a friend at church during high school: "If God had made me a man, I would be a preacher." But because I saw no sex change in my future, my gifts seemed wasted. Maybe I'd marry a pastor, like my mom did, but it just didn't seem like me. While my home church gave me unique opportunities for leadership and service (I was leading adult Bible studies and mission projects for adults by age eighteen), for which I will always be grateful, their inability to help me dream about the possibilities of my calling, left me bewildered and inattentive to my calling when I entered college in 1998.

However, by God's mercy, I came to know throughout college that I was pursued by a God who dearly loved me and wanted me to be an envoy of this love through my own unique gifts and graces. While I tried to ignore my love for the church and ministry, God reminded me of

this love during my senior year of college. Sitting in chapel at Samford University in Birmingham, Alabama, in the spring of 2002, I heard my campus minister, April Robinson, preach. Not speak, but preach. At first I said to friends, "How dare she think she can preach!" I sat cross-armed during the entire service. But, thank goodness, she preached for several consecutive chapels, and by the end of her series, my heart softened. I was in awe. And the wheels in my head began to turn. Could I do what she was doing? I still wasn't sure. I soon would graduate with a teaching degree, fulfilling my lifetime goal of being an older elementary school teacher. But yet something was not right. Jumping into a life of teaching was just not something that I could see myself doing anymore. God's calling for ministry seemed to be eating away at me again, but differently this time.

Several weeks later, I walked through the doors of Baptist Church of the Covenant in downtown Birmingham and found direction. I already attended a church on the other side of town and just went there to be with a friend for the day. However, much to my surprise, standing in the pulpit that day, I saw a woman preacher—the first women I'd ever seen, who was called the "senior pastor" of a congregation. I wept and wept as I watched Sarah Shelton preach. After the service—tear stained and all—I stayed for coffee hour and met some of the most real and open-hearted people I'd ever met in my life. I just couldn't get enough of this church, and I went back for a Sunday night dinner they were hosting, just hours later. I joined the church weeks later and soon became the church's first summer ministry intern.

I began to see that my calling was no longer just about me, but rather about the joy of coming to understand the power of God in context of a community of faith. I remembered as I watched Pastor Sarah lead this church that there was a calling on my life given by God many years before. Maybe I could do what she was doing. My heart leaped at the idea. And while I always thought this "calling" would be to mission service, I was learning to say that it was a calling to be a pastor, even if Pastor Sarah embodied the only example I'd ever seen.

Most amazingly, during the rest of the year that I stayed in Birmingham after college, God brought four other Baptist-ordained clergy into my life in real and meaningful relationships. From each of them, I got the courage to say what I felt most passionate about doing—speaking and leading as a general minister of the church (not as a youth or children's pastor, for example). With these midwives, it was finally okay for me to journey with God into the depths of my soul and then to express what I felt when I returned. Birthing something I never dreamed for myself before, I applied to seminary.

From the first day that I entered Duke Divinity School in 2003, I was finally able to say that God had called me to preach. I could be or do nothing else. Logistically, I knew I didn't want to leave the Baptist church—no matter how hard the journey ahead might be. I felt a strong desire to make this branch of the church the place I always dreamed it to be, though I'd observed its challenges firsthand from my youth. I wanted to be a part of the best parts of the Baptist tradition that I remembered from my childhood—believer's baptisms, autonomy of the local church, church potlucks with mile-long tables, and an emphasis on missions and evangelism. Being a part of the Baptist House community at Duke and taking a pastoral summer internship at Calvary Baptist Church in Washington, D.C., aided my progress in this direction. I continued to meet new Baptist colleagues who told me "you can" more times than "you cannot." I will be forever grateful for the strength of these voices.

After completing seminary in 2006, Calvary Baptist ordained me in the American Baptist tradition—a denomination that welcomed me— my gender and all—as the Southern Baptist church of my youth would not. But, I needed a job. Would a Baptist church really hire me? Though countless naysayers told me that I'd have to start my own church to pastor in the Baptist context, I always believed otherwise. One Baptist congregation in Maryland took a risk on a young seminary graduate like me, calling me as their pastor of education and youth. I served and gained valuable experience until another Baptist congregation in Virginia called me as their pastor, where I currently serve.

But, I don't think this is the end of my story or that I've somehow arrived since I now lead my own church. My prayer, like that of Thomas Merton is: "God, I have no idea where I am going. I do not see the road ahead of me. I cannot know for certain where it will end. Nor do I really know myself, and the fact that I think I am following your will does not mean that I am actually doing so. But I believe that the desire to please you does in fact please you . . . I hope that I will never do anything apart from your desire. And I know that if I do this you will lead me by the right road, though we know nothing about it." This is what I know about calling: there are always other teachers to learn from. There are more authentic gifts to grow into. There are more paths to blaze. Calling to ministry is a lifelong journey. I hope for the grace to keep listening, so that wherever this calling of following God takes me, I'll be ready to say, "yes!"

Elizabeth Evans Hagan is the Pastor of Washington Plaza Baptist Church in Reston, Virginia. Originally from Chattanooga, Tennessee, and married to Kevin, Elizabeth enjoys writing, baking, traveling internationally, and cheering loudly for Duke basketball anytime she can.

Kelli Joyce

My pastor, Michael, says that the people God calls to ministry are the ones who wouldn't be caught dead in church otherwise. I don't know if that's right, but it's right about me.

At nineteen, it feels odd to be writing something that feels like a retrospective. My path has been far from traditional, though, and so it bears a little exposition. In 1997 my family moved to Oak Ridge, North Carolina: population, three thousand. I was four years old, and I loved to read. It was one of the first things people noticed about me at our new church. Central Baptist was a growing Southern Baptist church, and the first one I ever remember attending, though I'd been in church all my life. It was two minutes from our house. Eventually my reading led my parents to decide that we ought to home school. At the time it was intended as a temporary arrangement, to keep me from getting too bored in kindergarten. As with so many things, it didn't turn out quite the way we'd planned. I never transitioned to public school, completed high school early, and graduated from the University of North Carolina in May of 2012.

The language of calling was central in the church where I grew up. Over the years that I was in youth group, several boys went forward while they were still in high school. The senior pastor would announce to the church, beaming, that this young man felt God was calling him to full-time Christian ministry. The call to be a pastor was like magic to me when I was younger. It fell under the category of "parts of the Christian faith that I cannot experience and do not understand." Still, back in those days,

I was unconcerned with the idea of calling. I was too busy to focus on abstract and un-provable ideas like that one; I was too busy doing things like putting together a list of verses to take to the youth pastor in defense of my theory that those who died without ever having heard the gospel might not go to hell after all. (The conversation did not go over particularly well.) My faith as I understood it was practical and demonstrable and precise. "Calling" was an interesting concept, but when they told me it wasn't for me, I didn't mind so much. It all sounded a little too out there, too ambiguous. No one ever talked about calling in terms of talent or of interest, not really. They didn't even talk about passion—I wouldn't have called it so at the time, but I had passion in spades. You were simply called or you weren't, and if you wanted the church to endorse your ministry, you needed to be able to articulate your "call experience" clearly.

I was going to be a lawyer. I'd decided so at the age of twelve, after several years of prepubescent angst over what I was going to do with my life and how I was going to make a difference in the world. I knew I'd be good at it—it fit my skill set. I was persuasive and passionate, I loved to construct and defend an argument, and I could read and write well. The demands of lawyer-dom were clear, and I was fairly convinced that I would have no trouble meeting them. The question of calling became even more irrelevant to my life.

When I was thirteen, a year after my decision to work toward law school, I realized that I was gay. In my carefully-planned life, there was now an enormous problem. I lived in a small town in North Carolina, attended a Southern Baptist church, and I was home schooled. I didn't know anyone who was gay. And I didn't want it. With the confidence of a thirteen-year-old, I decided that this was unacceptable, and that I would simply make it go away. Yet my desperate prayers and forced attempts to cast my friendships with boys in the "appropriate" light of romantic attraction all failed. So I slipped into silence on the issue, with others and with myself. I remember clearly the week that one of my high school Sunday School teachers surmised that I must have been given "the gift of singleness." I wanted to cry. Theology wasn't distant and objective anymore. It hurt.

The advice I'd found from Christian resources online had failed me—no amount of prayer seemed able to make me like the rest of them. My experiences in those first few years seemed only to reaffirm what I had already mostly believed: that prayer's effectiveness was hit-and-miss at best, and that there was something fundamentally untrustworthy about my own feelings.

The same semester I started college, I disengaged. After fifteen years of constant connection with the church and everything it represented to me, I decided that I was done. I couldn't stop going—no matter how much I wanted to; I wasn't allowed. But I could resist. I studied theology on my own—not the theology I'd been taught, but other theologies, progressive theologies. In retrospect, I can only imagine how frustrating I must have been to my youth pastor, Corey. He knew how I had once been, and now there I was, interacting only to challenge or subvert or undermine his every word. I still disagree with the theology he was giving us, but at the time the only response I knew was self-righteous smugness and snide laughter under my breath.

When I was sixteen, he took us all to a conference in Tennessee. The president of Liberty Theological Seminary spoke. He made a terrible joke about a gay Christian leader I respect, and he used an anti-gay slur to do it. He took a word I was only beginning to become comfortable associating myself with—queer—and he made it violent. I wanted to die. I have never felt the kind of rage I felt that night, before or after. When we got back to our hotel, I came out to Corey. I told him that I did not believe being gay was a sin. He told me we should do lunch.

Before I had ever even considered for a moment that I might become a minister, I wrote the most difficult sermon of my life. I spent dozens of hours locked in my room doing research, and I preached to an audience of one over the course of three lunches at Elizabeth's Pizza. It was factually accurate in its content, passionate in its delivery, and utterly useless in its effect. Looking back, I should have expected it. He listened to every word I'd prepared, and at the end of lunch three, he told me that unless I repented of my homosexuality and turned from my sinful lifestyle, I was predestined for hell. I never went back to youth at Central.

My call doesn't fit the neat narratives that I remember from my childhood. It didn't happen in an instant, or with a voice, or as I did Bible study at five in the morning. Instead, the process began that day at sixteen when I said to myself, "This is not what being a pastor should mean. There ought to be something better than this."

I researched online and found a progressive Baptist church downtown, College Park. They were American Baptist and Alliance of Baptists, which I'd never heard of. They were also Cooperative Baptist, which I had heard of—in a decidedly negative sense. The Internet suggested that they would take me. And so my brother and I went. We showed up on a Wednesday night, a sixteen-year-old with a brand-new driver's license and her fifteen-year-old brother. They welcomed us immediately, but as we ate dinner it didn't take long for the pastor to tactfully ask what they were all wondering—why are y'all here? I gave a quick version of the story, and he smiled at me. "You need to meet Lin, our youth pastor. You'd like her," he said. I had never known a woman pastor.

The pastor took me to coffee the next week. It was April Fool's Day. We talked about school and theology, and I told him my true age. (Back in those days I would simply introduce myself as a college sophomore unless directly asked how old I was, in the hopes that I might not be underestimated.) We talked for two hours. I told him about my plans for law school, about my plans to join the Air Force if they ever got around to repealing Don't Ask, Don't Tell. He smiled and nodded and then as we got ready to leave, casually said, "Have you ever considered the possibility that the world doesn't need another lawyer as much as it needs good ministers?"

The answer was no. I told him no.

Then Lin, the youth pastor, offered to teach me Greek over summer break. The wonderful, loving, crafty staff at my church never pressured me in either direction, but they made sure from the very beginning that if I were to change my mind about ministry, I would have the tools and support I needed. That summer, Lin told me about her time at divinity school. I went online and found out they had a joint degree with the school of law. And I was intrigued.

When I look back on it this way, it reads like it was this smooth process with an inevitable conclusion. But it wasn't. I didn't want to. It was more than that—I couldn't. Other women could be pastors, I'd come to believe that years earlier. Still, even when the underlying theological principle is no longer there, the lessons of childhood are hard to shake. I hadn't had a call experience; I was going to be a lawyer! What God would want me as a minister of anything?

A year later, the summer before my senior year of college, I was still entirely uncertain as to what I should do. Law school was safe and easy. The staff at church knew so. Their message was clear: "If you do not want to go, don't. But don't act like we're unreasonable for suggesting it. You can do this if you want it." I accepted a summer internship with College Park. They made me teach Sunday School for every age, go to deacons' meetings, visit in hospitals, clean out costume closets, and everything else under the sun. They made me preach.

I have always tended toward a faith that is less immediate and rather more academic than most of the people I worship with. I had forgotten what it could feel like to be consumed by love for the church and for the gospel. All my life, church had told me things that sounded reasonable, but felt hollow when it came time to live them out. That summer, the ridiculousness of me as a minister became a reality that made me come alive. The summer ended, I went back to UNC, and I started applying to divinity schools.

When I was still so conflicted about whether or not I should pursue ministry at all, I imagined that when I eventually figured it out, I would know exactly what to do from there, and then it would "only" be a matter of doing it. But the last year has required just as much of an effort toward discernment, if not more. Should I stay in North Carolina, close to home and to the church that's become home, or go far, to figure out who I am on my own? Where can I learn the most from the faculty, the students, and God? Where can I teach the most? How and when do I tell my extended family about the change of career plans? They are generally opposed to women holding any leadership roles in church. Should

I pursue congregational ministry, knowing there may not be jobs for a Baptist minister like me? How can I best honor God with this decision?

I don't know that I've gotten the kinds of answers I was looking for to any of those questions. Sometimes I envy the pastors of my childhood the certainty that they had, or at least professed to have, about their calling. My calling was a coaxing, by God, through people. And following it is the hardest thing I have ever done. Recognizing that my journey to ministry has been difficult, however, doesn't mean that I doubt where I am. For all the uncertainties that have come from this radical re-imagining of my life, I am confident that I have something to offer to the Kingdom of God through this. If nothing else, I can be a minister of listening, with an ear to hear the voices of the insecure, the rejected, the fearful, the weary, the awkward, and the unheard. In 2 Corinthians, Paul says that we are fragile clay jars, earthen vessels that contain great treasure. The Kingdom of God is the upending of all our assumptions about who is appropriate and what holds value. I know better than anyone how much of an earthen vessel I am. I used to think that when someone was called to ministry, it was something magical and had to be supernatural. Now that I am taking this path? I *know* it is.

Kelli Joyce is a North Carolina native and a lover of all things related to progressive Baptist life in the South. She is a first-year student at Yale Divinity School.

Lia Scholl

Many of the men I know had a calling that happened like this: God said, "Be a minister." So he went to the preacher, and the preacher said, "Okay, you're a minister." Then he went to seminary, got a church, and was a minister.

But the women I meet tend to have a different kind of calling stories. Like an origami fortune teller (also called cootie catchers, chatterboxes, salt cellars, and whirlybirds), their callings unfold, one piece at a time. Mine started like that and continues even twelve years into ministry.

The first time I ever stood in the pulpit was the night that John Belushi died. It was a Friday, and my new church was hosting a lock-in for the youth. We had a new building, and we were still having church in the gym, so the pulpit stood under a basketball hoop, on a temporary stage. But it was a solid wood, wide pulpit, painted white, with room for a giant print Bible, a glass of water, reading glasses and a watch. I opened my Bible to the Psalms. And I read them, in a sing-song, whoopin' kind of way. I swayed. I imagined people in the pews. And it felt good.

But I knew it couldn't be good. Because I had never seen a woman in the pulpit. Pick a color: white. W-H-I-T-E.

But called I felt, so I dedicated my life to Christian service when I was about 15. It was a hot youth conference with thousands of kids. I felt "moved" to make some kind of decision, and since I had already been saved (once saved, always saved!), and already re-dedicated my life rather

recently, coming forward to declare my vocation to be an answer to God's calling felt pretty good.

I was going to be a missionary! Pick a number: 7. One-Two-Three-Four-Five-Six-Seven. You can't be in the ministry. You're a girl. You can be a missionary. Heathens are lower than women.

I left the church soon after that. I was finished with the excesses of white privilege that smacked me in the face when I attended my First Baptist. Shiny chandeliers, stained glass windows, fancy dresses, and the nicest cars. I was tired of hearing about saving souls when I knew people were hungry. I was tired of hearing that people needed Jesus, when I knew they needed access to water. I was also tired of staring at the mote in the eye of the church, and hearing about the speck in the other's eye.

I walked out of the church. Pick a color: Blue. B-L-U-E.

Ten years out of church, and there was something missing in my life. I was drawn to God like hummingbirds are drawn to bright flowers, but I couldn't reconcile how. How could I serve that God of that church? The God who valued wealth over poverty, pretty over ugly, ignorant over educated, and gluttony over hunger. Then I heard a voice, not so still, and not so small, but round and full and holy. And it said, "Abide in me." Taking that to mean that I didn't need to have it all figured out, I returned to church. A very different church, but still church.

And Martha Wall met me at the door and said, "You've been sent by God." Pick a number: Two. One-Two. God and I together were very different than me alone.

A few people suggested I go on a mission trip to Belize. I wanted to swing a hammer, to help rebuild homes destroyed by a storm. The sexist missionary (and, apparently, God) had a different idea. It was there—teaching Vacation Bible School to children, coloring with them, telling them stories, running, playing and loving them—there I saw vocation again. This was the good stuff.

In the dusty heat passing a red crayon. Pick a color: Red. R-O-J-A.

So I followed to seminary. I chose to go close to home, close to my church, close to my friends and family who would support me. But the option close to home was also not very female-friendly. The professor who

supervised our ministry experience would move women from courses for pastors to courses for para-church workers. Some students would say to your face, "You can't be a pastor, you're a girl!" Some professors would spend hours on expositing texts to show that men should be the head of households and heads of church. But there were good ones, here and there.

Like my preaching professor, who offered a special class for the women—the Women's History in Preaching—where I could hear voices like my own from the pulpit. Where I could consider the Scripture texts about fierce women called by God. Where I could try on my own stoles, my own robes, and my own pulpit and feel it. The thought that I could be a preacher was like a pashmina scarf, and I wrapped myself in it as I left seminary.

Stepping from behind the pulpit, with my red stole on. Pick a number: Four. One-Two-Three-Four. My preaching professor asked, "How does it feel to be a preacher?"

And now, I find myself back in church with the People of God. I seethe at a low boil. I seethe at the undercurrent of sexism that runs through denominational politics, through the pastoral relations teams, through the congregation in gentle, genteel, and general ways. It's like it never leaves.

I find it in the nice, funny pastor who says, on Mother's Day, "Fathers, your children will look to you to understand God, and mothers, your children will look to you to understand relationships." As if women do not bear the image of God. As if God is not a nurturing dove, a woman in labor, a mother suckling her babe, a woman who comforts her children. As if God is not a midwife, a woman kneading leaven into bread. As if God is not wisdom, providing inspiration to her children.

I find it in the dearth of congregations willing to hire women—not only as children's ministers and childcare workers, but as associate ministers, youth pastors, and especially as senior pastors and solo pastors. I find it in the churches who do call a woman, but demean her, even if unwittingly, by telling her she looks pretty in the pulpit, or asking her to be sure that coffee is made for the meeting.

That is not to say that all congregations are like that. I serve a congregation who calls women, specifically because they are gifted. They call women because Mary was the first to tell the Good News of the resurrection of the Christ. They call women because they believe in women's abilities.

I find myself called to working with individuals whom the church has vilified, neglected, used, and abused. Over and over again, I find myself in those same church robes that were so important to me, apologizing for my kind. I'm sorry we hurt you. I'm sorry we excluded you. I'm sorry we used you. I'm sorry we excommunicated you. I'm sorry we offended you. I'm sorry we killed you.

And those people? They are people to whom the church said "Stay in those abusive relationships." They are people that the church didn't protect. They are people who made choices that the church didn't like. They are people who wanted love, compassion, aid, possibilities, options, but were met with judgment, stigma, anger, and oppression. They, of course, are women.

How can we hear a calling if you don't tell us we're called? Pick a number: 5. One-Two-Three-Four-Five.

Through the years, my calling has been reshaped, reformed, redesigned, refashioned, and even rearranged. It has all been about justice. It has all been about loving those outside the church doors, practicing hospitality with people who some people wouldn't want in their home.

It's not a salary. It's not job satisfaction. It's not a product that I can place. It's not a career, so much as it's a calling. But it keeps me from the trappings of success. I have to measure myself in a different way.

And the truth is, it's not easy. I'm called to love people, except they're not all lovable. I'm called to sit with people in pain, where I'd much rather fix things. I'm called to hold people in prayer, comfort them when they're sad, tell them that God loves them, convince them to give more money to the church.

I often wonder if it's fruitless. I've been on a trajectory of lower paying jobs for the last several years. And having been in the process of looking for a full-time church job (my current one is part-time), I've been ever

more aware of the ways it's difficult for women to answer that calling. But when I try to imagine another life, I cannot.

"If no church calls you, does that mean you're not called?" Pick a color. Green. Still growing, still stretching, still aching, and still alive. Still here.

Lia Claire Scholl is a minister who is committed to social justice and inclusivity. Originally from Alabama, Lia earned her Master of Divinity degree from Beeson Divinity School at Samford University and is the pastor of the Richmond Mennonite Fellowship in Richmond, Virginia. Her new book, I Heart Sex Workers: A Christian Response to People in the Sex Trade *is forthcoming from Chalice Press.*

Robin Sandbothe

My call as a Christian was something I took very seriously during my growing up years. I suspect my seriousness may have been, at least partially, a byproduct of my innate need to please others which naturally extended to a need to please God. It became more than a need to please, though—it became a strong inner sense that God had a purpose for my life and that I needed to be open to how God might use me.

The church in which I grew up nurtured me in the faith, and nurtured my gifts for ministry. I was encouraged along the way to lead in various ministries. That kind of encouragement continued in my adult life, as well, in what became my home church after college. I led Bible studies, served as committee chairperson on numerous occasions, served as the director of Sunday School, led choirs—in almost every aspect of the church's life, I held a leadership position.

As a child I was certain I was being called to missions. By the time I was a teen my sense of calling had become a more nebulous call to "Christian service." I had no examples of women in ministry on which to base an understanding of how God might be calling me. By college, I believed my vocation was to help people who were experiencing mental or relational problems and so pursued a psychology degree.

From childhood I felt compelled to lead in various ministries of the church, and that compulsion extended into college and my twenties and early thirties. In my early thirties, I became part of a group at my church, which was focusing on a deeper discipleship, and at the same time a friend

of mine began attending seminary—a woman. My journey with God was becoming deeper—I was listening more to what God wanted from me. I think seeing my friend exploring her calling made me start thinking about that possibility for myself, and during a service at our church when an altar call was made for those who felt called to vocational ministry, I found myself walking to the altar to begin that journey.

I remember feeling shaken—literally—by the recognition of what following that path would mean. My body was trembling and my teeth chattered as if I had been plunged into frigid water as I began to process my decision with my pastor after the service. What I couldn't shake, however, was the sense that this path was one I had to pursue. After visiting the seminary my friend was attending and doing some other exploration of possible schools, I applied and was accepted as a master of divinity student. I quit my full-time position as a juvenile officer and sold my house and moved in with my grandmother so I could devote myself to my studies. I didn't waver from that point forward, although I continue to define, even today, how to fulfill my call to vocational ministry.

When I was exploring seminary training, I recall one Wednesday evening business session at church. I didn't even realize I was on the agenda that evening. The church had to affirm formally that they agreed that I had exhibited gifts for ministry, so there was a motion made to do so. I don't remember the exact words said. What I remember was the resounding "aye" when the vote was taken. Individuals within the congregation had expressed along the way that they were not surprised by my expression of feeling called to ministry, but that unanimous assent, which in my ears sounded like one loud voice, sort of startled me out of my own reverie. This external voice was both an echo of what I was feeling and a confirmation for me that it wasn't just something I was sensing about myself. Here were people who knew me, nurtured me, and loved me who were saying yes, we also see God's call on your life.

During seminary I continued to be given opportunities to explore various aspects of calling—opportunities to preach, to teach, and to work with the local denominational office. Despite these opportunities, I was discovering that my denomination did not agree with God about my

calling. My seminary's administration made it clear that God didn't call women to preach. At times I wasn't sure they believed I should be in seminary at all.

I am also just a bit stubborn, though. (Can you hear my friends and family guffawing?) When my seminary said the preaching requirement for the master of divinity would not be necessary for me because of my gender, I, of course, made sure to enroll in homiletics. I submitted a sermon for the homiletics award—didn't win, but that wasn't really the point. When a friend suggested I be the class president, at first I was reluctant, but the more I thought about it, the more I liked the idea. Were I to be chosen, it would be like thumbing my nose at what my seminary and denomination believed about my gender. In retrospect, it was not a good reason, but it definitely felt gratifying when I did become president of my class and, as tradition demanded, presented the class' gift to the seminary during commencement exercises.

Upon completing seminary training, I was called to be a part-time minister of education at Providence Baptist Church, a little country church on the edge of the Kansas City metro area. Despite my bravado, I didn't see myself serving as a senior pastor. Although I had no doubts about being called to ministry, I had yet to discern to what ministry that might ultimately be. Again, with no women in the role of senior pastor in my experience, it wasn't a path that sprang to mind.

I became aware of a full-time opening at Central Baptist Theological Seminary. I was able to secure that job largely because of my seminary training. The dean saw the value of having an administrative assistant who understood the seminary experience. Finding this position made it possible for me to accept the church's part-time position. I began my ministry career with my feet in two worlds—the church and academia.

Over the two years that I served in my first church position, I was given two opportunities to preach. The second time, a family left the church because they didn't believe God called women to preach. At Central Baptist Theological Seminary exactly the opposite was true. Women students made up half of the student body, and no one ever questioned that they were answering God's call. I remember the most striking

thing I noticed when I started work at Central was hearing women's voices when we sang in chapel. Women's voices were drowned out by the men's in the chapel services where I attended seminary. I remember thinking that finally I had come to a place where my voice might be heard. My feet were in two different worlds in more ways than one. Continuing to serve in both places grew more and more difficult.

Fortunately, I learned of an associate minister position at another church, whose theology resonated with mine. During my interview I was asked how I felt about ordination. While I did not believe at that time that one must be ordained to minister, I told them that were I to be given the opportunity, I would be a willing participant in the act. I had come to believe that I had an obligation as a woman in ministry to do what I could to blaze the trail for other women who would come after me. In the course of our conversation, I mentioned the time the family had left my current place of service after I preached. A young woman on the committee audibly gasped, and I knew this church was the right place for me. I only hoped they would agree.

They did, and I began a time in my ministry life when I believed I was truly following God's leading. I was, in fact, ordained at Englewood Baptist Church. My seminary family, as well as my church family, biological family, and dear friends all laid hands on me in what was the most affirming experience of my life. This church was a place where I could live into my calling. They blessed me in so many ways.

I was happy. I was thriving in church ministry and continuing to discern God's call as the dean's assistant at Central. I think of that time as my period of the two James. Dr. James Browning was my pastor at Englewood. Dr. James F. Hines was the academic dean at Central. Both were my mentors. Both became dear friends. Both taught me, from very different perspectives, about empowering those around me to be the best they could be, about the importance of listening, about how to keep all the plates spinning in the air, and about when to let some of them go.

Although I hadn't intended to continue in both worlds, I found myself unable to let one of them go. In congregational life, I was immersed in relationships and nurturing those around me as they were being spiritually

formed. In academia, I was immersed in study and exposure to new ideas and the critical reflection of that world. It was a perfect balance of heart and head.

Inevitably, my world changed without my choice. At almost the same time James Hines chose to return to the classroom, James Browning left the pastorate to become a full-time professor. These changes precipitated a number of other radical shifts in my ministry career. At the urging of our intentional interim pastor at Englewood, who was also a colleague and friend at the seminary, I decided to submit my résumé to the search committee at the church. I was one of three interviewed to be the next coordinating pastor. The other two were a couple whom the church then called as their new co-coordinating pastors. Although not all that many in the congregation knew I had been interviewed for the position, I found it too hard to continue there in my associate position after what felt like a rejection of my ability to lead. I stayed about five more months, and then left using the changes at the seminary as my reason.

It was certainly true that the challenges at the seminary were making working sixty-plus hours very difficult. My position had already changed twice by that time and would change two more times in the coming years. Unbelievably, I've worked there for fifteen years now. I have had some amazing opportunities, not least of which has been working with some great theological, biblical, and pastoral scholars, including Dr. Molly T. Marshall, who serves as Central's president and has been the ultimate trailblazer for women in ministry in Baptist life.

Central has been a place where I have continued to develop as a life-long learner, where my faith has also had a chance to grow and change as my relationship with God has changed and grown. Central has been a great resource for my congregational ministry, as well as for denominational work in which I have been involved, and in my relationship with my ministry colleagues.

I have not found again the equilibrium I once experienced between congregation and academia. I miss church ministry and have found only pockets of service since I left Englewood. I'm in an in-between place, a time of exploration—in a way, a time of being lost, which, according to

Barbara Brown Taylor, is a spiritual practice. I'm not sure if I've wandered off the path or if there was never really one there in the first place. Taylor says that deliberately getting lost, which is one way of looking at what I've done, is a good place to work on the skills you need in that kind of circumstance—managing your panic, marshalling your resources, and taking a good look around to see where you are and what this unexpected development might have to offer you.[1] Panic is more manageable when you remember you're not alone in the wilderness. It has also forced me to re-examine what I'm able to do, what I'm good at, what I have a passion for. I am trying to take the time to look around to see what it is God wants me to do next and what it is the church needs from me as well.

In the meantime, I trust and I live with uncertainty.

Rev. Robin R. Sandbothe is the Director of Seminary Relations at Central Baptist Theological Seminary in Shawnee, Kansas (the metro area of Kansas City). She frequently leads workshops, short-term studies, and retreats, especially in subjects related to spiritual formation, and enjoys preaching when she has the opportunity.

Note

[1]Barbara Brown Taylor, *An Altar in the World* (New York: Harper Collins, 2009), 72.

Susan Rogers

I cannot remember a time when I was indifferent to the idea of God, the work of the church, or the ways I sensed God calling me to live out my faith. From the time I was a small child, I took my faith journey very seriously, feeling compelled to respond to God in specific and significant ways. Since the moment I made the decision to become a follower of Christ, I have wrestled, served, and pursued the best way to express this commitment. I thought this was just part of being a Christian. I thought every believer felt this way. It would not be until years later that I would begin to see that this was not the case. It would not be until years later that I would begin to connect my passion for serving God with my sense of vocational calling. Instead of having an all at once, all-or-nothing moment of divine invitation, a gradual unfolding would lead me to hear and answer my calling into vocational ministry.

I grew up in a household where both of my parents took my sister and me to a close-knit Baptist church from the time we were very young. At this church, I learned the stories of Scripture, formed my most meaningful friendships, and made the decision to commit my life to Christ. It was at the young age of six, with my heart pounding and knees knocking, that I remember walking down the aisle toward our pastor to share this decision with our congregation. I had no idea what I was really saying "yes" to, only that there was something stirring me to declare my love for Jesus. It was a happy day, and one that led me to be baptized a few weeks later.

As I grew into adolescence, I continued to be part of this community of faith which would nurture my faith through my teenage years. I was part of a very active youth group, and this became my primary avenue for spiritual growth and friendship. This was where I first began to wonder what it might feel like to be called into ministry. One Sunday each year was dedicated to celebrating the gifts of the youth by allowing them to serve in a variety of ways. Even the key worship leadership roles were assumed by the youth for that day. One Sunday during my high school years, I served as the minister of education. Not only did I play this role in worship, but I was also given the chance to lead an adult Bible study class. I was nervous at first and felt unqualified to lead this group of adults, but I did it. I read our central Scripture passage to the group and posed several questions in order to engage discussion. While there were some responses, I remember being concerned that those adults did not seem to share the same enthusiasm that I had about my faith. Was this just what it was like to grow older or was there something wrong with what I sensed to be a complacent, almost indifferent attitude toward faith? This question would resurface many years later.

Even though I had some stirrings into vocational ministry as a youth, they did not seem strong enough to satisfy a genuine calling. After all, so many of the stories that had been handed down to me from Scripture involved characters who had these powerful, undeniable experiences that led them to say yes to God. I had not had that experience, but I remember wishing that I, too, would be called into ministry.

As I headed off to college at Samford University, I took this longing with me. I struggled to decide on a direction and considered music, counseling, and ministry. Again, having not yet had my burning bush experience, I chose to explore other possibilities. Acting on the advice of a friend, I volunteered at a rehabilitation center down the street and began exploring the healthcare profession. I was immediately drawn to the role of the occupational therapist, the rehabilitation professional helping patients overcome physical and cognitive challenges to regain their independence. After a short time, I decided to move in this direction,

which led me to the University of Florida, where I pursued a degree in occupational therapy.

Looking back, I can see how being at a larger university played a pivotal role in my faith journey. While on the one hand, I continued to nurture my faith among like-minded Christian organizations and communities, I also cherished the time I spent with people of other faiths and those who claimed no faith. It was during my time there that my eyes were opened to how much I needed those relationships to give me a fuller understanding of the world around me and of the God who created all of it. Being exposed to different worldviews allowed me to begin developing my own beliefs, particularly as they related to mission and evangelism, and ultimately to the role of the church. I left there with a sense that God was much bigger that I had once thought, and that belief in God had many different expressions.

These critical years not only earned me a degree in occupational therapy, but new opportunities to experiment with my giftedness and calling. I periodically had the opportunity to lead worship music for a campus ministry group. I facilitated dorm Bible studies and initiated a spiritual formation group within my college of health-related professions. I also served as a summer missionary one summer, traveling around Florida in a minivan, serving in a variety of capacities in different churches. Through all of these opportunities, I grew more passionate about being a part of others' faith journey and continued to question whether or not I might be "called" into ministry some day.

After college, I was married to my high school sweetheart, and we began life together back in Jacksonville. I began a career as an occupational therapist, and we became active participants at Hendricks Avenue Baptist Church. My work as a therapist provided me with a great avenue for ministry. Being with people in the midst of physical or mental disability, and being part of their healing was truly a gift. I enjoyed my work, but what I enjoyed most was not the therapy, but rather the opportunity to sit and talk with them. I loved the space we shared to exchange stories. It seemed that each new patient brought a new story, a different struggle, and another way of experiencing the world. I began to realize that what

I enjoyed most about my work was not my primary role in rehabilitation. What I loved most was encouraging and listening to people share their stories and being a spiritual companion to them on life's sometimes chaotic journey.

Over the next nine years, my own spiritual journey would be impacted by several factors, including the stories shared by my patients. The births of both of our daughters, our involvement at church, and our personal struggles all shaped how I was beginning to understand God and God's work in the world. About the time that we began having our children, my husband was really struggling to determine a career path. Having not completed his college degree, his opportunities were limited, and he began and ended several jobs, which left both of us frustrated. We were struggling in our marriage and struggling to find a direction that would lead to financial stability for our family. At the same time, we were becoming even more active in the ministries of our church. I taught our adult Bible study class, we worked with youth together, and we helped lead worship. Serving and sharing became not only an avenue to express our faith and to help others, but they also led to our own transformation.

Serving in the church while also dealing with our own insecurities and doubts gave rise to some important spiritual awakenings. I began to realize that even a church as open and loving as ours was not always ready to receive the questions, doubts, and struggles that are an inevitable part of our lives. Many weeks I left our adult Bible study group feeling dissatisfied with the level of sharing and intimacy—not just my neighbor's, but my own. Why is it that we would set aside this time every weekend to come together, and yet not talk about what was really going on in our lives? I was not only becoming restless about this longing for authenticity, but began wondering if the way we were doing and being church was actually contributing to the problem. I began asking many questions, wondering if there might be an alternative, and I began to imagine new possibilities.

Looking back, I believe that the questions and struggles I was facing created an openness to hear and accept a call into vocational ministry. I remember sitting at dinner with some good friends one night, sharing

a conversation about some of my concerns and questions. One friend made the comment that I should consider going to seminary to explore my growing sense of calling. After many private moments of wondering about this possibility, this was the first time it became a public conversation. A light went off, a door opened, and my husband and I began to talk about what this might look like for our family. Still, I was not sure this desire and this restlessness were enough to constitute a calling into vocational ministry. I wanted to be sure that this was indeed God's voice before I uprooted our family and set out for a seminary education to pursue some yet unknown ministry direction.

Over the next several months, the desire to set out on this path was relentless. We prayed, talked, and met with all of our ministers. We led a youth Bible study in our home centered around calling and shared with these students that we were wondering about our own direction. We continued to serve in our church, and I continued to work as a therapist, all the while listening and looking for signs that this was (or was not) the direction for us to go. No doubt we had concerns about selling our home, leaving our friends and families and jobs, but we also felt a sense of assuredness that God would provide for us. I am pretty sure that some of our friends and family thought we had lost our minds, but in August of 2005, we sold our home and moved to Atlanta so that I could begin seminary at McAfee School of Theology.

The sense that God would take care of us as I responded to a growing sense of calling proved to be true. In Atlanta, I not only nurtured my calling, but we discovered a network of support that would provide much needed care and guidance to our family over the next few years. To my surprise, I developed a love for pastoral ministry, and found my way to a church that provided opportunity to learn and grow in my role as minister. The gradual unfolding would continue to happen as we opened ourselves up to what would come next. Listening to our lives and our longings has been the key to figuring out the next step, and that next step became returning to Jacksonville so that I could start and pastor a new church through the Cooperative Baptist Fellowship. We have been

here for the last two years, and although I could have never predicted this unfolding, I believe God has been and is in the midst of it all.

Looking back, I can see how my own assumptions about calling almost hindered my willingness to listen and respond to God's voice. I was looking for the burning bush, and God was whispering in the secret longings and questions that came from life's experiences. I am so glad God does not stop speaking, that callings continue to unfold and that somehow, by God's grace, I was willing to respond.

Susan Rogers is a church planter and pastor serving The Well at Springfield, a new faith community in Jacksonville, Florida, affiliated with the Cooperative Baptist Fellowship. She is married to Kevin and they have two daughters, Alyce and Kate.

CPSIA information can be obtained at www.ICGtesting.com
Printed in the USA
LVOW020428171112

307750LV00003B/1/P